The Artistic Creation of Twenty Adobe Illustrator® Experts

Illustrator
MASTERS

The Artistic Creation of Twenty Adobe Illustrator® Experts

Illustrator
MASTERS

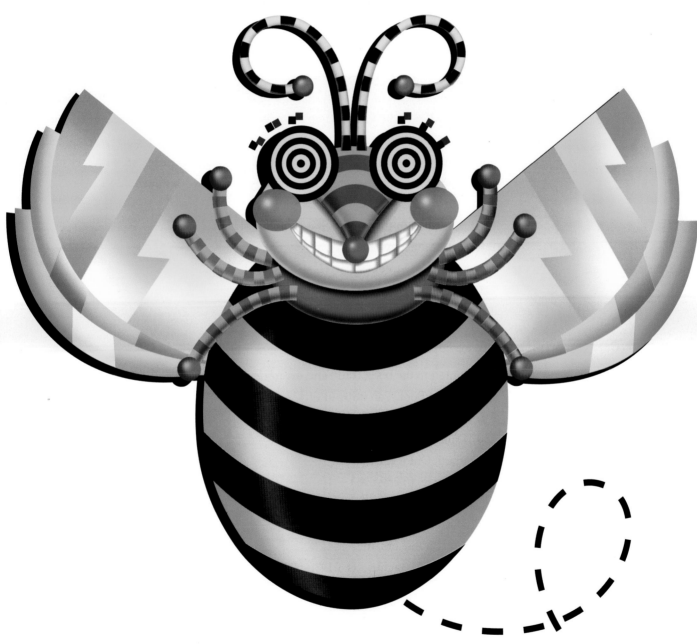

EDITED BY
AGOSTO

First published in the United States of America by:
Rockport Publishers, Inc.
33 Commercial Street
Gloucester, Massachusetts 01930-5089
Telephone: (978) 282-9590
Facsimile: (978) 283-2742

Distributed to the book trade and art trade in the United States by:
North Light Books, an imprint of
F & W Publications
1507 Dana Avenue
Cincinnati, Ohio 45207
Telephone: (800) 289-0963

Other Distribution by:
Rockport Publishers, Inc.
Gloucester, Massachusetts 01930-5089

ISBN 1-56496-547-3

10 9 8 7 6 5 4 3 2 1

Manufactured in Hong Kong.

Foreword

Before I worked at Adobe, I used to create illustrations and diagrams using a technical pen, triangles, T-square and French curves. I hated the days when my ink pen clogged or the triangle slipped thus smearing the lines. Then twelve years ago I started working at Adobe and my job was to show off the beautiful quality of PostScript artwork and type. This was difficult because I had to program my graphics by writing PostScript code. A year later the first version of Adobe Illustrator came out and I haven't touched an ink pen since.

A common misconception among people new to digital graphics is that computers make the illustration process so easy and automatic that *anyone* can become an illustrator. As a matter of fact, when designers and illustrators began to think about using computers in their work many became concerned that their jobs might become obsolete. They feared that because these digital tools had so many automated features, any person with little or no formal art training could call themselves an illustrator and make money.

This has been a common fear whenever a new tool or technology is adopted by professionals. But the truth is that while a new technology or machine might automate a certain design task, it can never replace the creativity, emotion and experience that artists bring to their work. No software program can make intelligent design decisions, choose just the right color combinations or generate concepts and ideas. This is the domain of the professionally trained and talented artist.

This book contains the work of several of the world's most talented and experienced digital illustrators. Not only have these people mastered the digital tools of today's graphic professional, but they have also proved themselves as superb illustrators no matter what tools they use. Truly great artists are masters of composition, color, content and the media. The illustrators highlighted in this book are truly masters of digital illustration.

Luanne Seymour Cohen

Creative Director
Adobe Systems Incorporated

Contents

Shin Matsunaga

One of the preeminent graphic designers in Japan, Shin Matsunaga graduated from the Tokyo National University of Fine Arts and Music in 1964. He began his career working in the advertising division of Japanese cosmetics manufacturer Shiseido Co. Ltd. and in 1971 established Shin Matsunaga Design Inc. He has received numerous prizes and awards for his work including the 41st Japanese Education Minister's Art Encouragement Prize for Freshman, the Mainichi Design Award in Japan and the Gold Medal and Honorary Award at the 12th International Biennale in Warsaw. Matsunaga's design work is part of the Museum of Modern Art's collection in New York City and can be seen at thirty-eight other museums around the world. A member of the Alliance Graphique Internationale, his clients have included Bank of Tokyo-Mitsubishi, the Sezon Museum of Art, French cigarette maker SEITA, and fashion designer Issey Miyake.

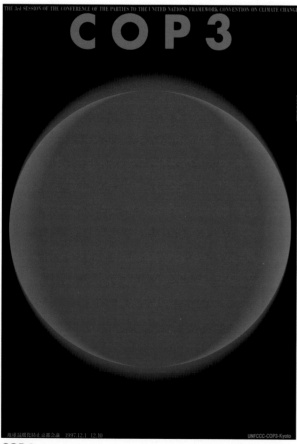

COP 3
Kyoto Environmental Committee: Poster design for '97 exhibition
Software: Illustrator

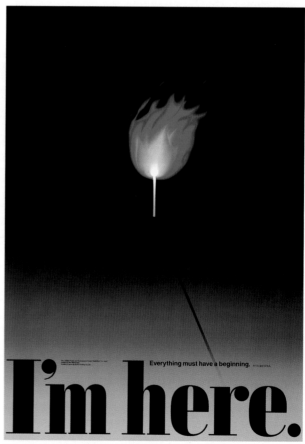

I'm Here. "Everything Must Have A Beginning."
Japan Graphic Designers Association Inc.: Poster design for peace/environmental awareness campaign
Software: Illustrator

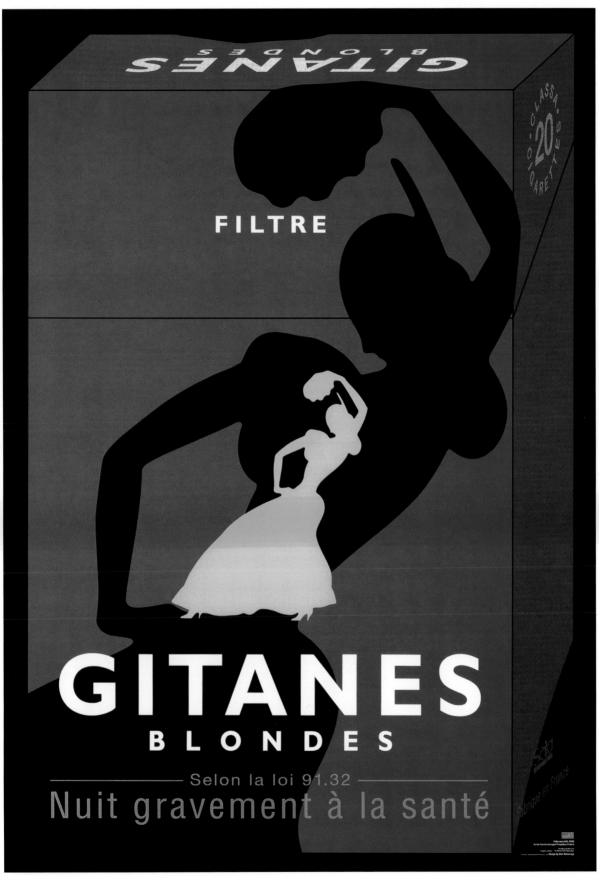

Gitanes Blondes
SEITA, Paris: Poster design for new cigarette package
Software: Illustrator

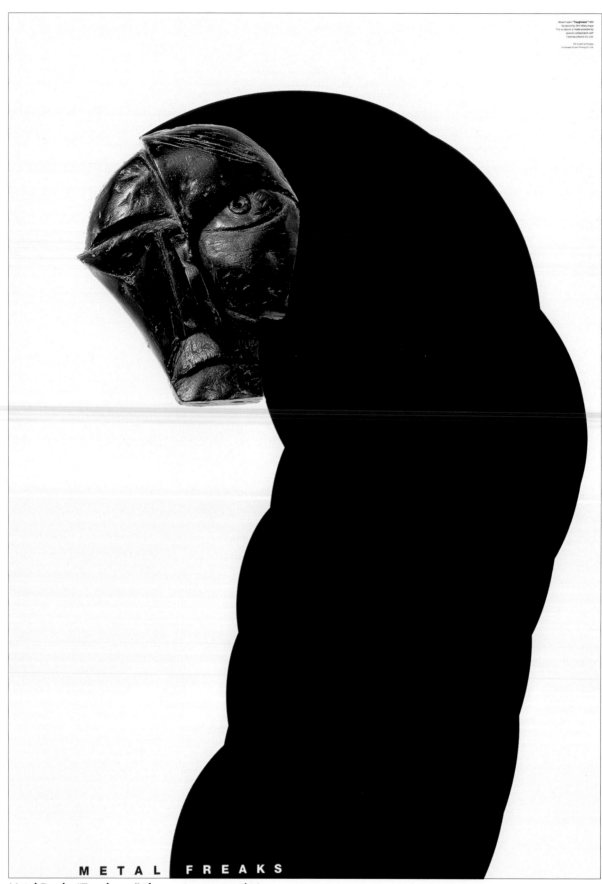

Metal Freaks "Toughness" 1992
Sculpture by Shin Matsunaga
This sculpture is made possible by
special collaboration with
Takahara Works Co. Ltd

Silk screen printing by
Kumazawa Screen Printing Co. Ltd

M E T A L F R E A K S

Metal Freaks "Toughness" (from a two-part series)
Original work
Software: Illustrator

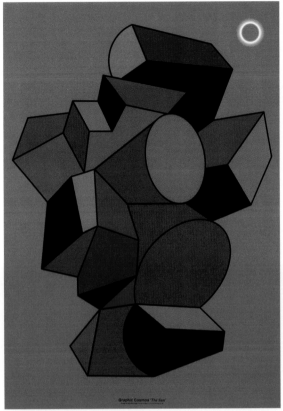

Graphic Cosmos, "The Sun"
Original work
Software: Illustrator

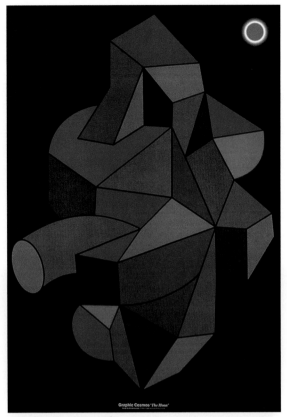

Graphic Cosmos, "The Moon"
Original work
Software: Illustrator

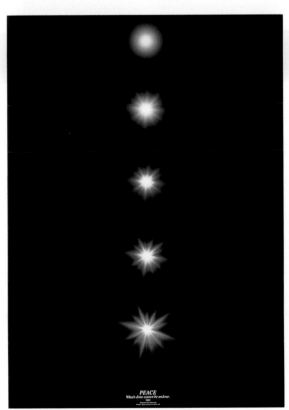

PEACE "What's done cannot be undone"
Japan Graphic Designers Association Inc.: Peace poster
Software: Illustrator

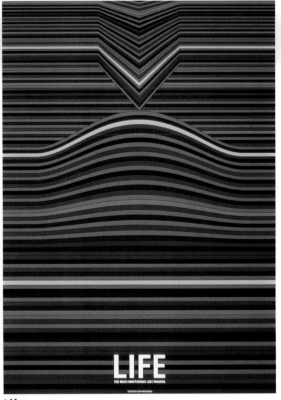

Life
Creative Review, London: Poster for design magazine
Software: Illustrator

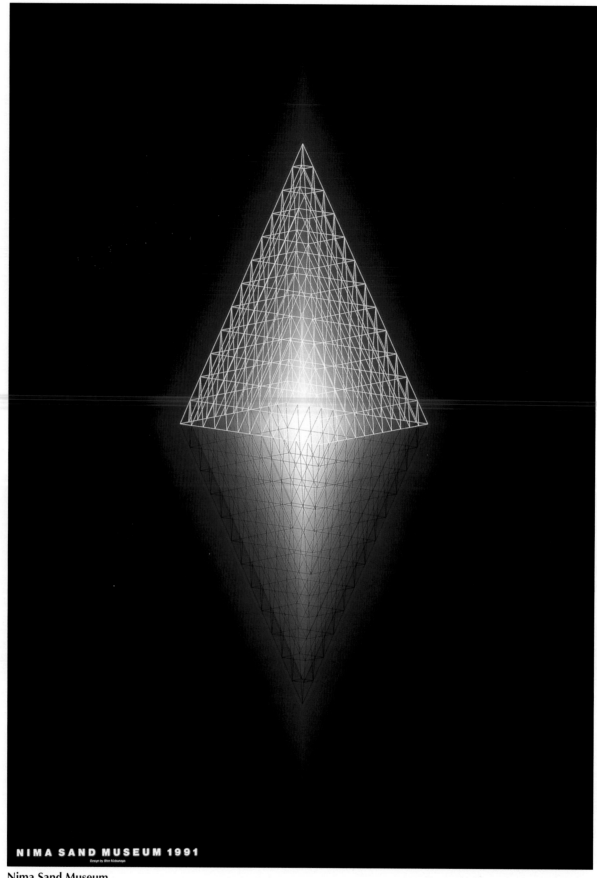

Nima Sand Museum

Nima Sand Museum: Poster design for the museum
Software: Illustrator

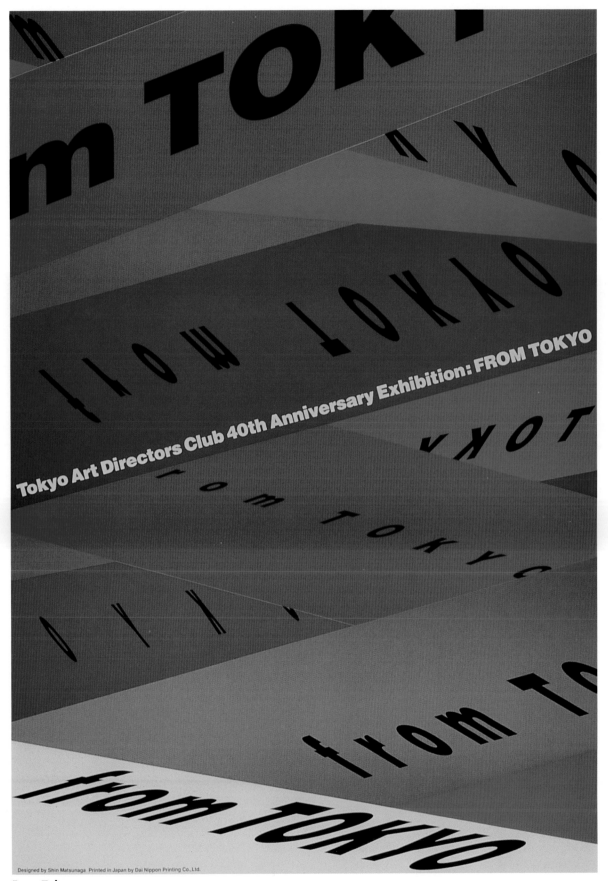

Designed by Shin Matsunaga Printed in Japan by Dai Nippon Printing Co.,Ltd.

From Tokyo
Tokyo Art Directors Club: Poster for exhibition
Software: Illustrator

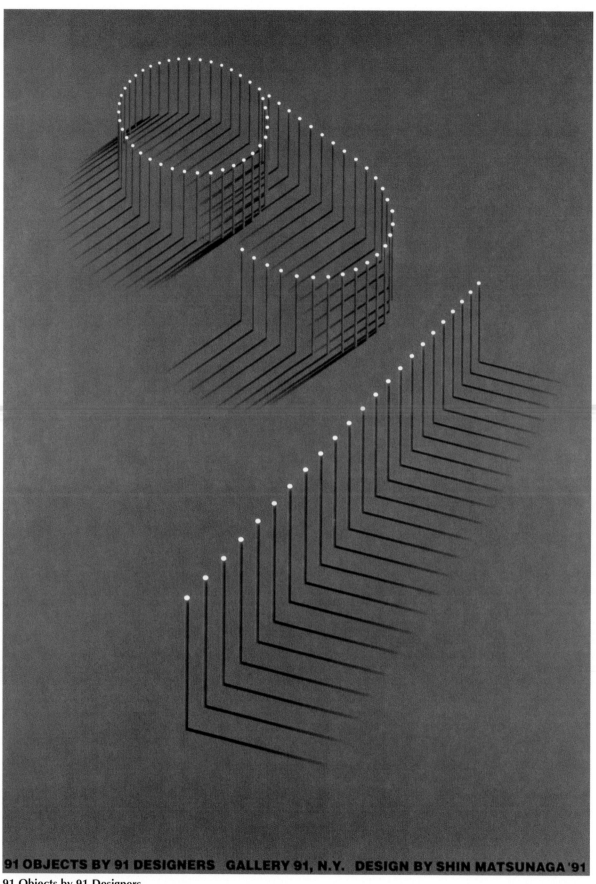

91 OBJECTS BY 91 DESIGNERS GALLERY 91, N.Y. DESIGN BY SHIN MATSUNAGA '91

91 Objects by 91 Designers
Gallery 91, New York: Poster specially created for exhibition
Software: Illustrator

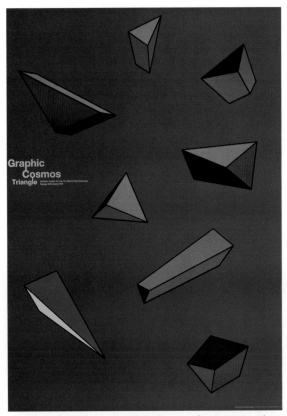

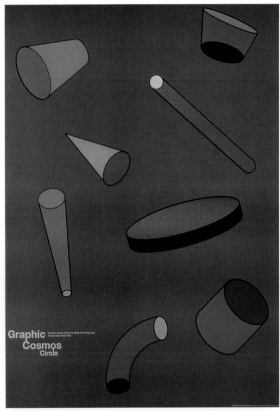

Graphic Cosmos "Triangle" (from a three-part series)
Japan Design Committee: Poster design for exhibition
Software: Illustrator

Graphic Cosmos "Circle" (from a three-part series)
Japan Design Committee: Poster design for exhibition
Software: Illustrator

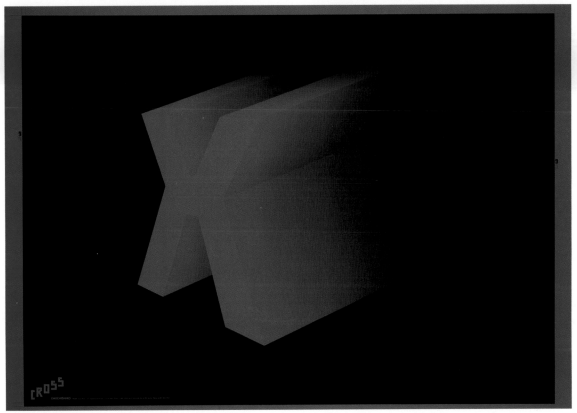

X (cross) no. 4
Daiichishiko Co., Ltd.: Poster design
Software: Illustrator

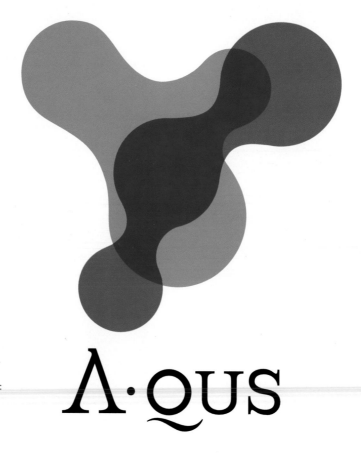

A-QUS
Keihan Electric Railway Co. Ltd.:
Trademark symbol design
Software: Illustrator

Λ·QUS

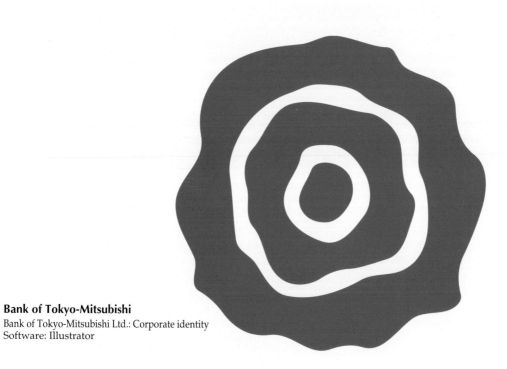

Bank of Tokyo-Mitsubishi
Bank of Tokyo-Mitsubishi Ltd.: Corporate identity
Software: Illustrator

ISSEY MIYAKE

Issey Miyake
Issey Miyake Inc.: Corporate identity
Software: Illustrator

Rhiga Royal Hotel
The Royal Hotel, Ltd.: Corporate identity
Software: Illustrator

DADA
Menoya:
Trademark symbol design
Software: Illustrator

iain cadby/why not associates

Iain cadby is one of four partners of why not associates, a "multi-disciplinary design partnership" located in the center of SoHo in London. With a spirit of "optimistic experimentation," their outlook has led to projects ranging from exhibition design to postage stamps, in areas from advertising to the World Wide Web, in creating work that is both adventurous and inventive. Their clients have been diverse and varied, and have included the BBC, Kobe Fashion Museum in Japan, the Pompidou Center in Paris, and the Royal Academy of Arts. Using primarily *Photoshop* and *FreeHand*, the partners stress, "While our aim is to offer new solutions to age-old problems of communication, design and marketing, our primary concern is to make them work coherently and commercially for the client."

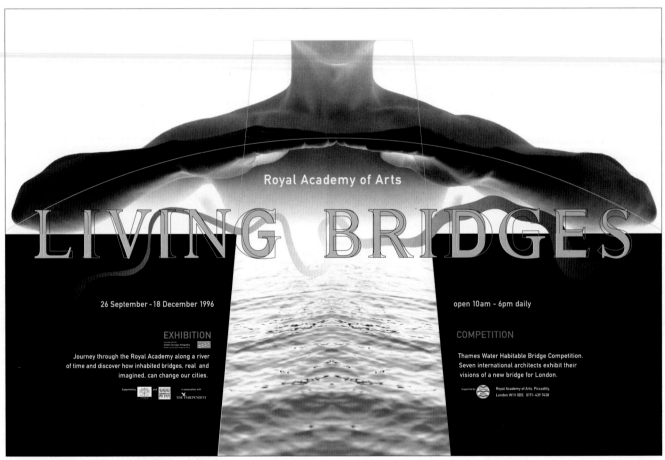

Living Bridges
Royal Academy of Art: Poster design for exhibition/competition
Software: FreeHand, Photoshop

Sensation
Royal Academy of Arts: Poster
Software: FreeHand, Photoshop
(right page)

ROYAL ACADEMY OF ARTS

YOUNG BRITISH ARTISTS FROM THE SAATCHI COLLECTION

SENSATION

18 SEPTEMBER - 28 DECEMBER 1997

CLOSED 25 DECEMBER

OPEN EVERY FRIDAY UNTIL
8.30PM FROM 26 SEPTEMBER

Upper and Lowercase, 1996
International Typeface Corp.: Magazine cover and spreads
Software: FreeHand, Photoshop

The Power of Erotic Design
Design Museum: Video installation
Software: FreeHand, Photoshop

BBC2
British Broadcasting Company: Series of documentaries on the British social security system
Software: FreeHand, Photoshop

Living Bridges

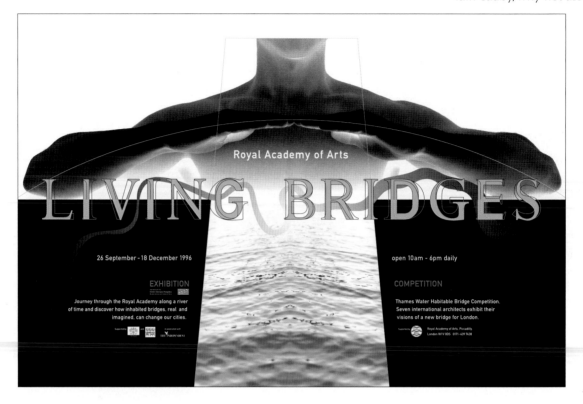

Assignment:

Create a poster for an exhibition/competition called *Living Bridges* at the Royal Academy of Arts in London. The exhibition asked the visitor to "journey through the Royal Academy along a river of time and discover how inhabited bridges, real and imagined, can change our cities." In addition to the exhibition, the Royal Academy was sponsoring the Thames Water Habitable Bridge Competition which featured the designs of

seven internationally renowned architects of a "new bridge for London." Our job was to design a poster for the exhibition that visually expressed the concept of "living bridges." We decided to create a poster that incorporated the human form as the "living bridge," organically connecting time as well as space.

1 The poster began with our photographer, Rocco, taking a photograph of the Thames from the London Bridge. An area of the picture with the visual qualities we had in mind was selected and scanned into *Photoshop*. Making a duplicate of the image, we then doubled the width of the canvas size while anchoring the original image to the upper left-hand corner. The duplicate image was rotated horizontally, cut and pasted into the original file, and merged with the original to form one image (see fig. 1-A and 1-B).

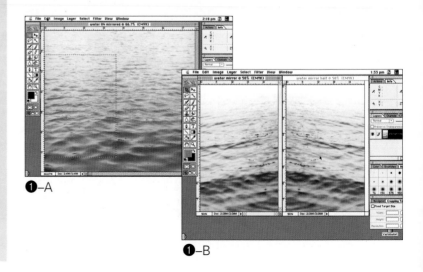

❶–A

❶–B

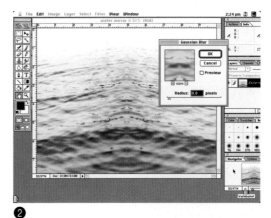

2 The top of the image (the area near the horizon that would meet the figure) was gradated and then the Gaussian Blur filter was applied with a 0.3 pixel radius to increase the blurriness of the image. Selecting Image > Adjust > Brightness/Contrast, the sliders were adjusted to increase the visual impact of the image. The image was then saved as a CMYK TIFF file.

3 Next we took a series of photographs of a model with his hands and arms in various positions reflecting the shapes of bridges and selected the photograph most illustrative of the architectural forces defining a bridge. Importing the image into *Photoshop*, the figure was cropped at the chest, leaving only the upper body.

4 Using the eraser tool on the paintbrush setting, the figure was then "cut out" (see fig. 4-A). Once isolated, the figure was then inverted. As the area around the chest and under the arms was too dark, a path was drawn and the selected area was lightened using Levels as well as adjusting the brightness and contrast (see fig. 4-B). This area was also gradated so that the figure would gradually fade out where it met with the horizon (see fig. 4-C).

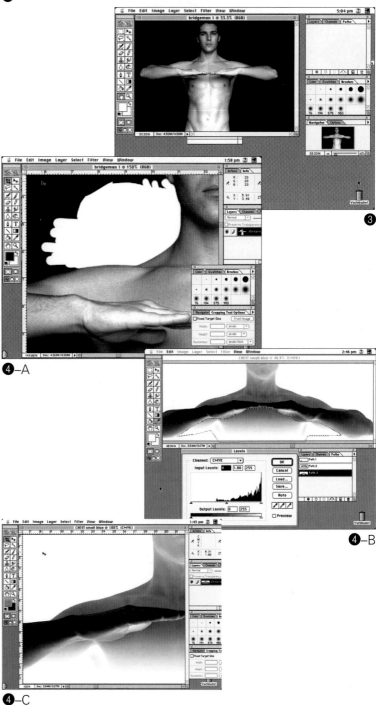

2

3

4–A

4–B

4–C

5 The typography to be used in the poster was created in *FreeHand*. To signify the old and the new, we combined the DIN and Perpetua fonts, alternating between serif and sans serif (see fig. 5-A). The characters were converted to paths, as we wanted to redraw them so the top bottom and sides of each letter would be drawn in the correct places (see fig. 5-B).

6 The river image coursing through the "Living Bridges" title was drawn in *FreeHand*, using the bezier curves (see fig. 6-A). A circular gradient was applied to the drawn image, ranging from cream (10% yellow) to black. At this point the main architectural lines of the poster were drawn into the composition, (see fig. 6-B).

7 The *Photoshop* TIFF file containing the Thames river image was then pasted into the composition between the two black areas representing land, with the two vertical lines framing the image (see fig. 7-A). The figure and the main type "Living Bridges" was then added to the composition (see fig. 7-B and 7-C). Final touches, such as the surplus type and the logos, completed the project (see fig. 7-D).

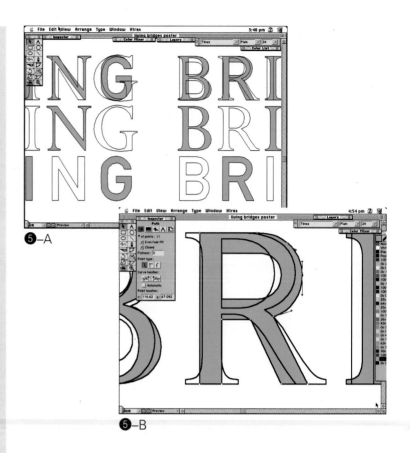

❺–A

❺–B

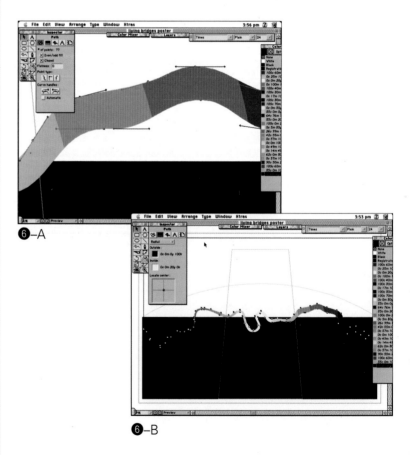

❻–A

❻–B

24

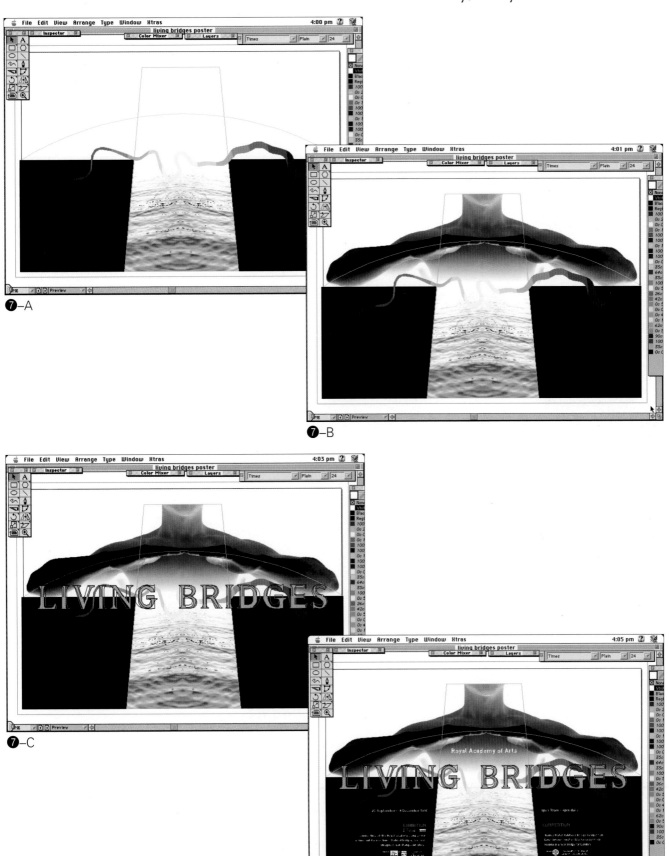

⑦–A

⑦–B

⑦–C

⑦–D

Nancy Stahl

Nancy Stahl is a well-known illustrator who currently lives and works in New York City. Her illustrations have been widely used, having appeared in advertisements, corporate identities, packaging, and multimedia. Stahl's clients have included Motorola, *The New York Times*, Coors Brewing Co., *Esquire*, Sony, and IBM. Using the computer exclusively for the past six years, Stahl's work has been featured in *Communication Arts* magazine, *Step-By-Step Graphics* and *Step-By-Step Electronic Design*, as well as in *The Illustrator Wow! Book* and the *Adobe Illustrator* CD gallery. In addition, her work has been exhibited in SoHo and in a one-woman show at the Lustrare Gallery. Stahl attended the Art Center College of Design in Los Angeles and was recently part of a Society of Illustrators exhibition called, "Woman Illustrators, Past and Present."

Bellhop
Self promotion
Software: Illustrator, Painter, Photoshop

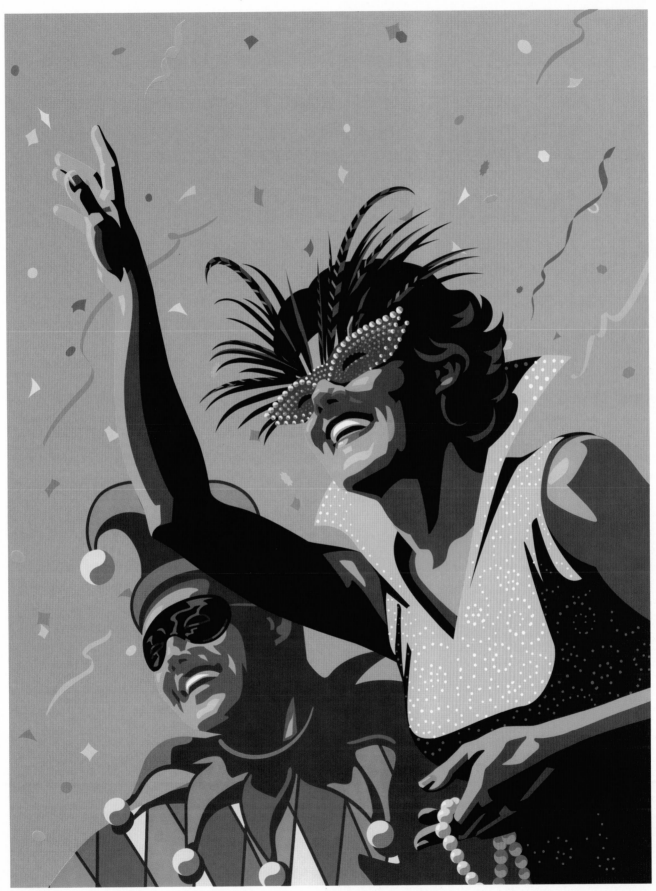

◆Nancy Stahl

Mardi Gras
Security Management magazine: Cover image
Software: Illustrator

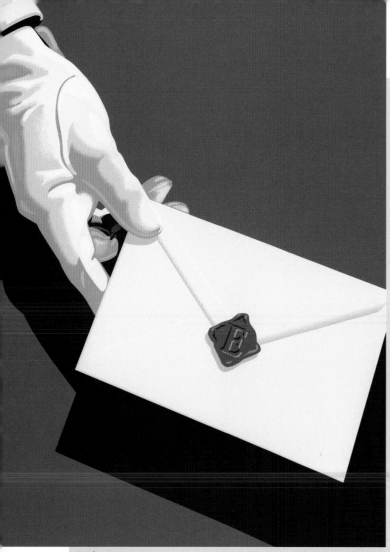

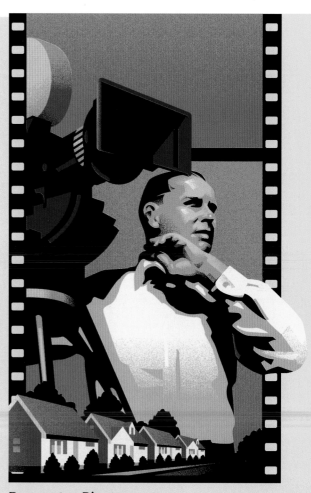

Envelope
Nabisco: Cover for in-house magazine, *NFG*
Software: Illustrator, Photoshop

Documentary Director
The Atlantic Monthly: Arts & Entertainment section cover
Software: Illustrator, Photoshop

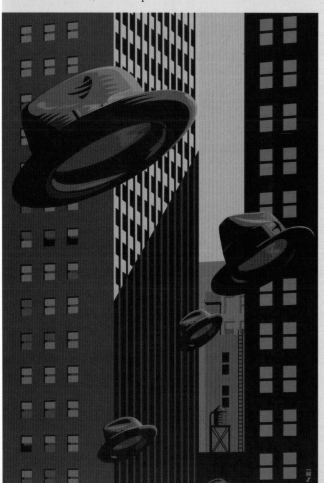

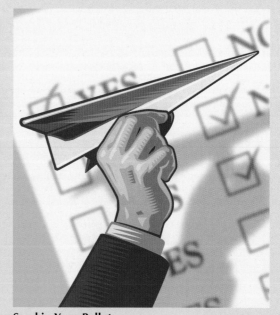

Send in Your Ballot
Frequent Flyer magazine: Cover illustration
Software: Illustrator, Photoshop

Flying Hats
Travel & Leisure magazine: Weather column illustration
Software: Illustrator

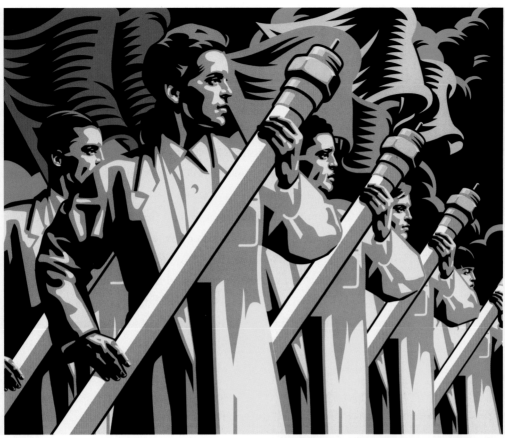

Troops
Motorola: Brochure and trade show collateral
Software: Illustrator

Asparagus House Fabric
Simpson Papers: Image for *Tools of the Trade: Computer Art on Quest*
Software: Illustrator, Painter

Co-ed
Security Management magazine: Cover image
Software: Illustrator

Robert Brünz

S eattle-based illustrator/designer Robert Brünz is best known for what he calls "new world" illustration. Brünz says that his works are "ethereal interpretations . . . (which) combine elements of early German and Russian poster design and cubist features often found in WPA murals with a modernistic look." While the digital medium can often be mechanistic and flat by nature, he adds warmth and exceptional depth through layering, light and the use of carefully selected colors. After selling off his sportswear business, he began his career in design as art director at an advertising agency. After a stint as designer at Boeing, he opened Brünz Studio in 1993 (formerly RM Brünz Studio) where he and his associates now work on projects that include illustration, corporate identity, and design programs. His clients have included Xerox, K2 Ski Corporation, Adobe Systems, and Microsoft.

The Illustrated Man
Xerox: Illustration for the Docutech system
Software: Illustrator, Photoshop

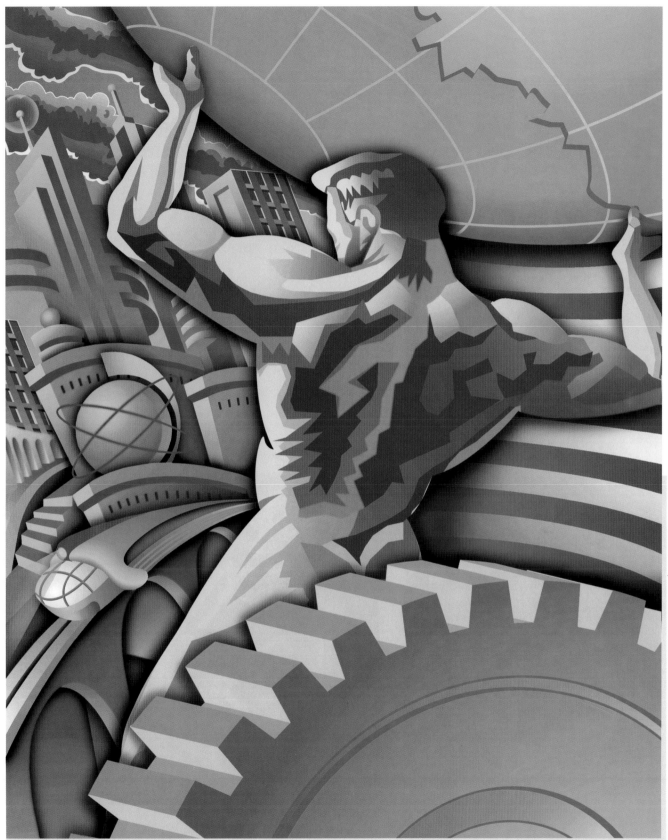

Atlas Standing Between Old and New Technology
Brünz Studio Inc.: Promotional art
Software: Illustrator, Photoshop

Santa Cog
Brünz Studio, Inc.: Christmas promotional postcard art
Software: Illustrator

Falling Cards
ARIS Corporation: Art for trade advertising
Software: Illustrator, Photoshop

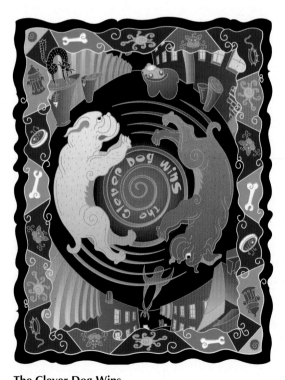

The Clever Dog Wins
Xerox Corporation: Art for the Docutech system sales kit
Software: Illustrator

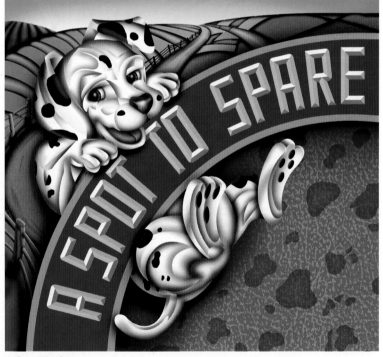

A Spot To Spare
Keenmind Productions: Cover art for children's book
Software: Illustrator, Photoshop

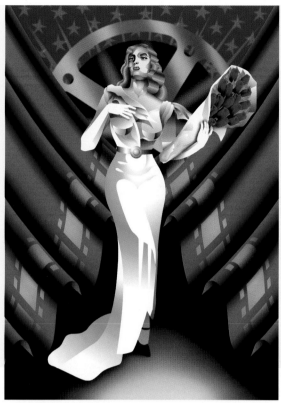

Oscar Night Starlet
FilmAid: Oscar night event artwork
Software: Illustrator, Photoshop

Amphora Angel
GNC/Amphora: Seasonal promotion artwork
Software: Illustrator

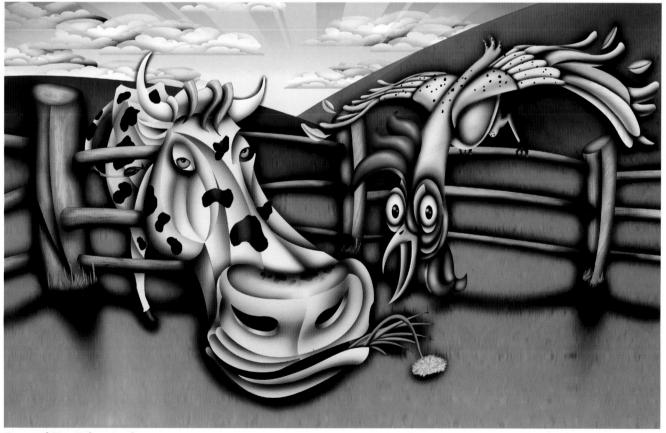

Cow and Hen Take a Look
Keenmind Productions: Art for children's book
Software: Illustrator, Photoshop

The Illustrated Man

Robert Brünz

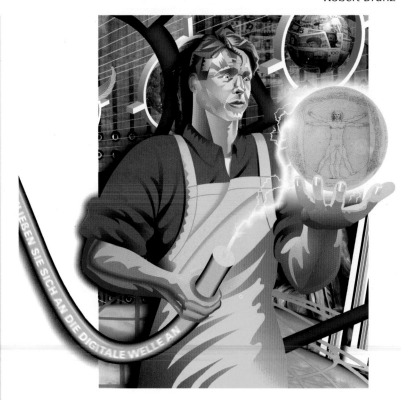

Assignment:

Create an illustration representing the Docutech technology of Xerox Corporation. The image needed to capture the cutting-edge benefits of the Docutech system—global connectivity, savings in time and money, environmental friendliness, and the ability to expand the users' printing power. The image was to be introduced at the Drupa trade show in Dusseldorf, Germany—a once-in-five-year event known as the world's largest printing technology trade show. First appearing on book covers, sales slicks, and posters, its use later was expanded and continues to appear around the world for Xerox promotions.

1 Following approval of the initial pencil drawing, I scanned the image into *Illustrator* as a grayscale TIFF file. Using the pen tool, I outlined the image, separating each section of color and form into its own shape. To finesse the complex layering and create a photographic effect in the final image with the glowing ball being zapped by a surge of energy, I knew I would have to export the illustration into *Photoshop*. Knowing this ahead of time, I specified all outlines at 0.5 pt., as the outlines would need to be as fine as possible without disappearing.

In addition to bringing the finished illustration into *Photoshop*, I included the outline as well as a separate layer for final object touch-ups.

❶

2 I assigned each body part to a different layer while creating the outlines. This assured that sections would not get in the way of each other when heavy coloring was added. As I would later insert the glowing globe and energy bolt between the space of the left hand and upper arm, I assigned separate layers to the hand, forearm, and upper arm. Copying and pasting the outline copy onto its own layer, I then hid it from view by clicking off the Eye icon in the Layers Palette.

3 While resizing and manipulating specific body parts, I wanted the globe and the hand to appear as if they were moving toward the viewer and away from the man, so the hand and arm needed to be enlarged and situated carefully. Selecting the hand and forearm, I chose Filter > Distort > Free Distort to create a sharper perspective distortion using the Distort windows feature.

4 To make a custom color swatch file for the illustration which I could easily access, I opened a new document with the Color and Swatch palettes displayed. Selecting CMYK from the pop-up menu, I then selected the values of the colors I wanted to use and chose New Swatch. After completing my customized color palette, I named the file "Project Colors" and dragged it into the Swatch Libraries folder. This enabled me to easily access my new color file by choosing Window > Swatch Libraries > Project Colors.

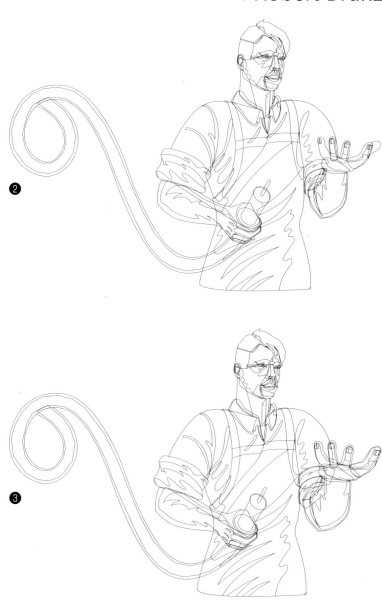

❷

❸

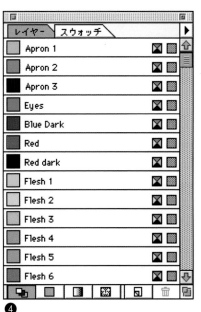

❹

5 Next, I began to assign colors to the composition, starting with the figure's head. To lower the risk of color banding when importing to *Photoshop*, I used *Illustrator*'s Blend feature. To create a smooth consistent blend, I made a line-shape for the starting color and made a subsequent copy to be used as the ending color. I then selected one corner of each separate color shape. Changing to the blend tool, I clicked on the selected point and chose the number of steps for the blend from the pop-up window. Once I completed a blend for each shape, I selected both the shape and the blend and chose Object > Masks > Make to place the fill/blend inside the shape.

6 For the lettering on the cable, I first created a curved line with the pen tool. Selecting the path-type tool, I clicked onto my new line and began typing. After determining the font and size, I moved the type onto the cable using the selection tool.

7 Once the illustration itself was complete, I chose Filter > Colors > Saturate, increasing the saturation 5 degrees to pump up the overall color.

8 At this point, I created separate files for each layer that I would need in *Photoshop*. First, I created a box outline around the whole illustration for alignment purposes and then created and saved four files: the main illustration with the box outline, the hand and forearm only with the box outline, the wire outline layer only (from Step 2) with the box outline, and the type only with the box outline.

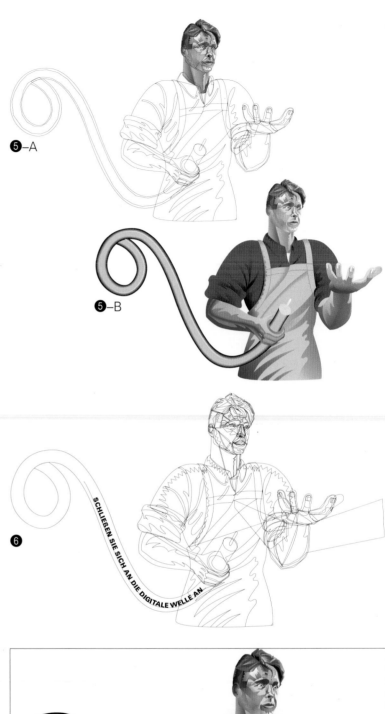

❺–A

❺–B

❻

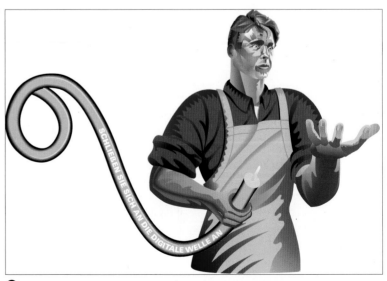

❼

9 I combined the four layers into one file in *Photoshop* and aligned each layer using the box outline. Placing the wire outline on top, I selected the areas that banded during importing with the wand tool and re-blended with the blend tool. After the banding was corrected, I deleted the wire outline layer.

10 Turning the black type to white, I then chose to Filter > Blur > Motion Blur in order to give the type more movement and energy. The globe and energy bolt were added onto their own layers and placed between the hand and forearm layer and the main illustration. I used the airbrush tool to create a white halo effect.

11 Flattening the image, I then selected the illustration and copied and pasted it on top of a background file I had previously created in *Photoshop*. Adding a soft black shadow between the background and the illustration with the airbrush tool set to 20% provided depth and created separation. The file was then flattened and converted to CMYK for film separation.

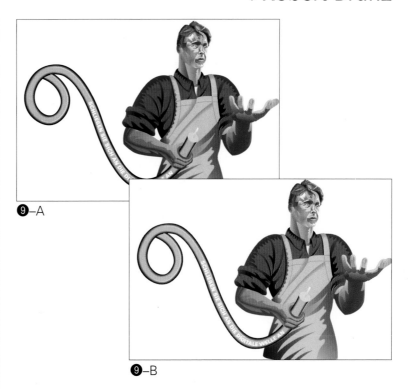

9–A

9–B

10–A

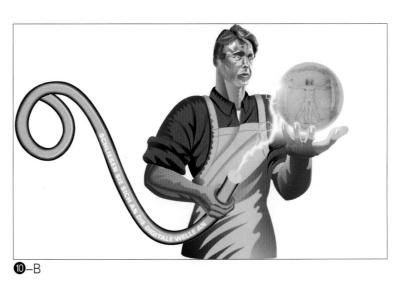

10–B

Javier Romero

J avier Romero began his career in design and advertising in 1971, working at Publicidad 2000 Advertising while attending the University of Madrid. Shortly after founding his own design studio in 1975, Romero received a grant from the Spanish government to study a the School of Visual Arts in New York City. Following his studies, he stayed on and established Periscope Inc., a studio that specialized in design and illustration for the recording industry. Opening its doors in 1985, Javier Romero Design Group has since established itself as a leading design studio in New York City handling design, illustration, and consulting for companies such as Coca-Cola, *The New York Times,* and Walt Disney. Romero's work has been featured in design magazines around the world and he has received awards for his design from the Art Directors Club and the American Institute of Graphic Arts.

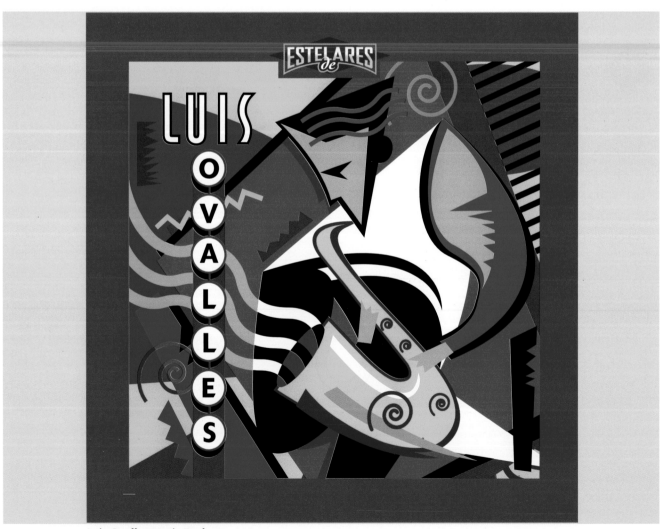

Luis Ovalles Music Package
J&N/Sony: Music package
Software: Illustrator

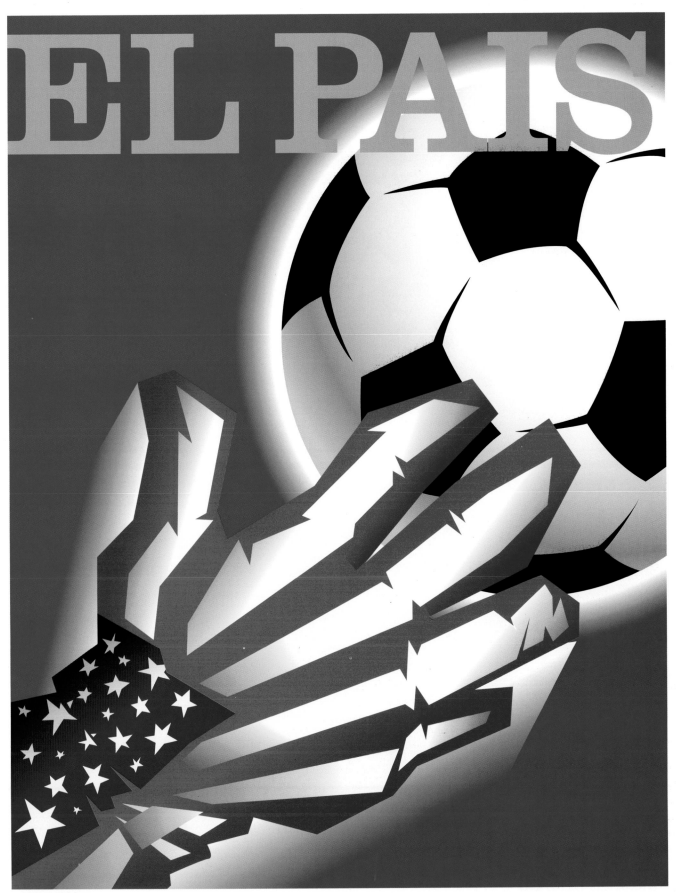

◆Javier Romero

USA World Cup
El Pais: Magazine cover
Software: Illustrator

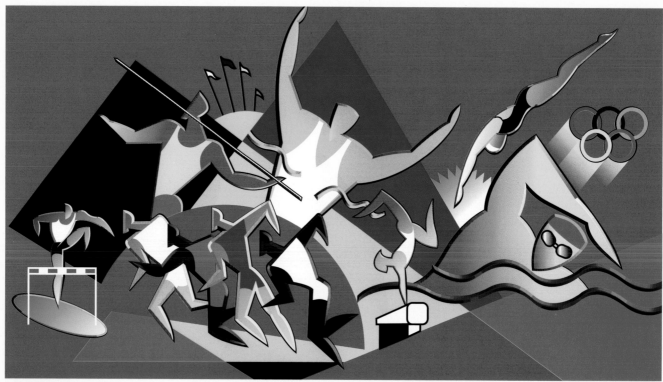

Coke Olympic Sports
Coca-Cola: Proposed graphic identity for a Coca-Cola vehicle to be used during the Atlanta Summer Olympics
Software: Illustrator

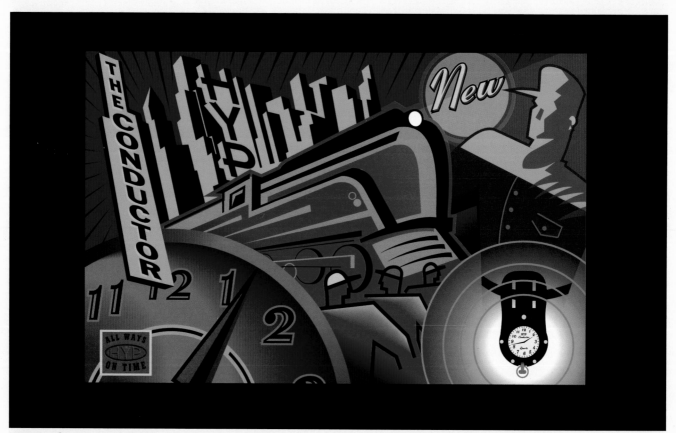

HYP Conductor Watch Poster
HYP: Poster display
Software: Illustrator

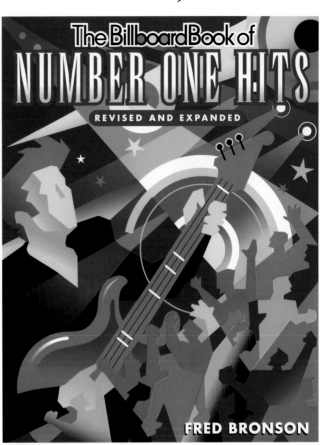

Apple College Poster
Wonderman/Apple: Promotional poster
Software: Illustrator

Billboard Book Cover
Billboard magazine: Book cover
Software: Illustrator

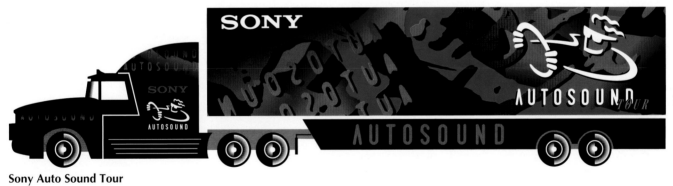

Sony Auto Sound Tour
Sony: Identity for event marketing program
Software: Illustrator, Photoshop

Do It All
Sony/Microsoft: Proposed graphics identity for a Sony/Microsoft event marketing program
Software: Illustrator

Jack Mortensbak

Jack Mortensbak is known by his clients and colleagues as "illoboy." Living in New York, he says he has been influenced by the "Japanese Illustration scene, American underground comix, Rock posters and club flyers." While Mortensbak works primarily in Adobe Illustrator, he also uses Photoshop and Flash to create his artwork. His clients have included Time, The Discovery Channel online, Nickelodeon, BusinessWeek, GQ and Bikini magazine. A self-taught illustrator, "illoboy" says that he lives and works by the following quote taken from Dr. Seuss:

> I like nonsense, it wakes up the brain cells. Fantasy is a necessary ingredient in living, it's a way of looking at life through the wrong end of a telescope. Which is what I do, and that enables you to laugh at life's realities.

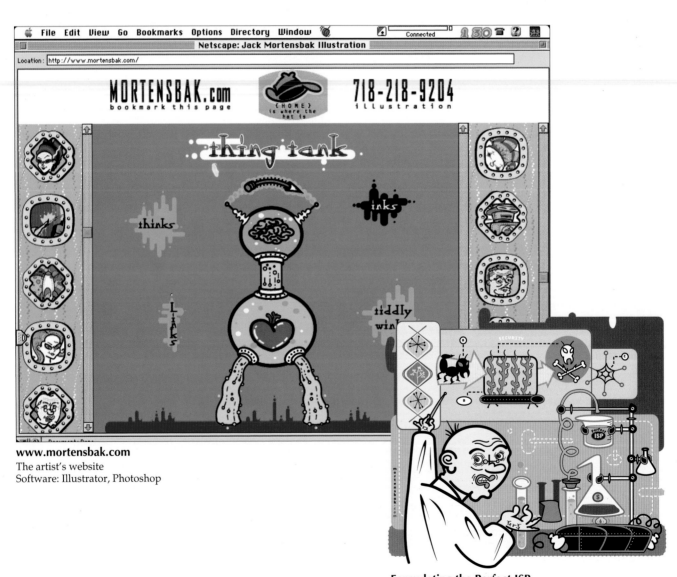

www.mortensbak.com
The artist's website
Software: Illustrator, Photoshop

Formulating the Perfect ISP
Waters magazine: Article illustration
Software: Illustrator

Lolly
Personal project: T-shirt design
Software: Illustrator

Schmooze
Musician magazine: Illustration for article on self promotion
Software: Illustrator

Extraterrestrial Giant Brain Devouring France
Nickelodeon: Illustration for remembering musical scales
Software: Illustrator

People Behaving Badly
American Demographics magazine: Cover art
Software: Illustrator

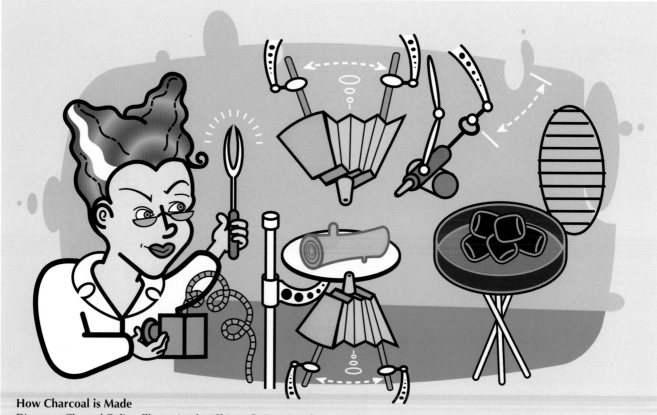

How Charcoal is Made
Discovery Channel Online: Illustration for "Skinny On" section about wierd science
Software: Illustrator

Peering Professor
Discovery Channel Online: Illustration for "Skinny On" section
Software: Illustrator

Hearing things
Discovery Channel Online: Illustration for "Skinny On" section
Software: Illustrator

Baggy Eyelids
Discovery Channel Online: Illustration for "Skinny On" section
Software: Illustrator

Mad Mac
MacWorld: Illustration for opinion column
Software: Illustrator

45

Drag the Web

Jack Mortensbak

Assignment:

Create an illustration for an article on various drag racing related websites on the Internet for Drag Racing Monthly magazine. As a self-taught illustrator, this was the perfect assignment to try out some graphical techniques the I had been working on though I always try to approach illustration by "keeping it simple."

1 I began by drawing a basic sketch of the drag racer image. For the flames on the drag racer, I incorporated various geometrical shapes with classical images to give them a "harder" line and feel, while trying to maintain the fluidity of the shapes.

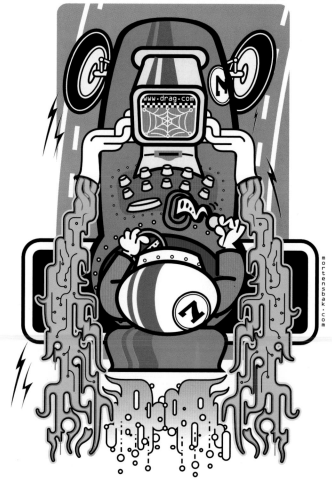

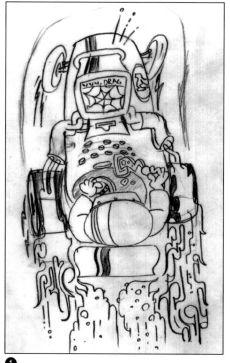

❶

2 After finishing the sketch, I saved it as a JPEG file, I scanned it into *Illustrator*. Once in *Illustrator*, I selected Layer Options and clicked on Lock and Dim Images. Creating a new layer I then began to trace over the placed layer (see fig. 2-A and fig. 2-B).

3 To render the flames on the side of the drag racer, I used the both the Unite and Minus Front filters to create the specific curves and lines that I wanted (see fig. 3-A). The multiple outlines of the flames were created by selecting the original black outline and choosing Edit > Copy. Without pasting, I then chose Edit > Paste in Back, pasting the copy of the black outline directly behind the original. I changed the color and the line weight of the stroke until the desired effect was achieved (see fig. 3-B).

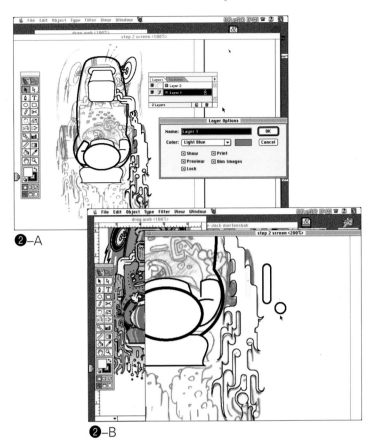

❷–A

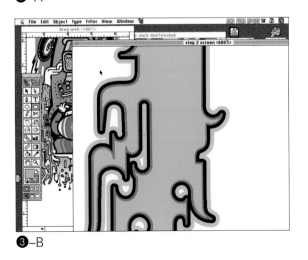

❷–B

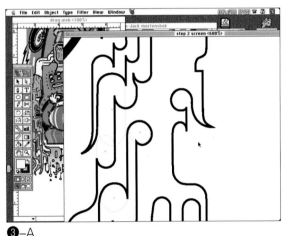

❸–A

❸–B

4 The rivets on the car were created in roughing the same way. To make the spaced circles, I chose both Round-caps and Round-join in the Stroke palette. Clicking on Dashed Line with 0 pt dash and 15 pt gap, I used the rounded rectangle tool to create the first set of black dots. Copying the set of black dots, I chose Edit > Paste in Front. Then I adjusted the weight to 2 pt and changed the color to white.

5 Type used in the composition was placed, sized and then converted into objects by selecting the type and choosing Type > Creates Outlines.

6 To finish the illustration, I converted to CMYK and for trapping purposes, I chose Filter > Colors > Overprint Black to ensure that all of the black outlines would overprint.

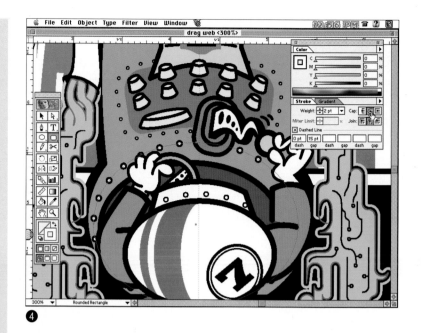

❹

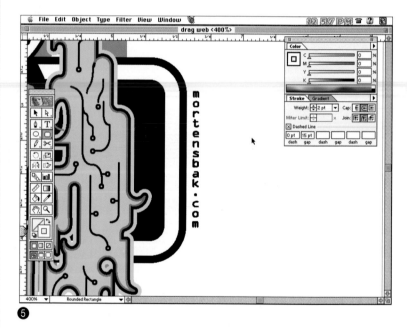

❺

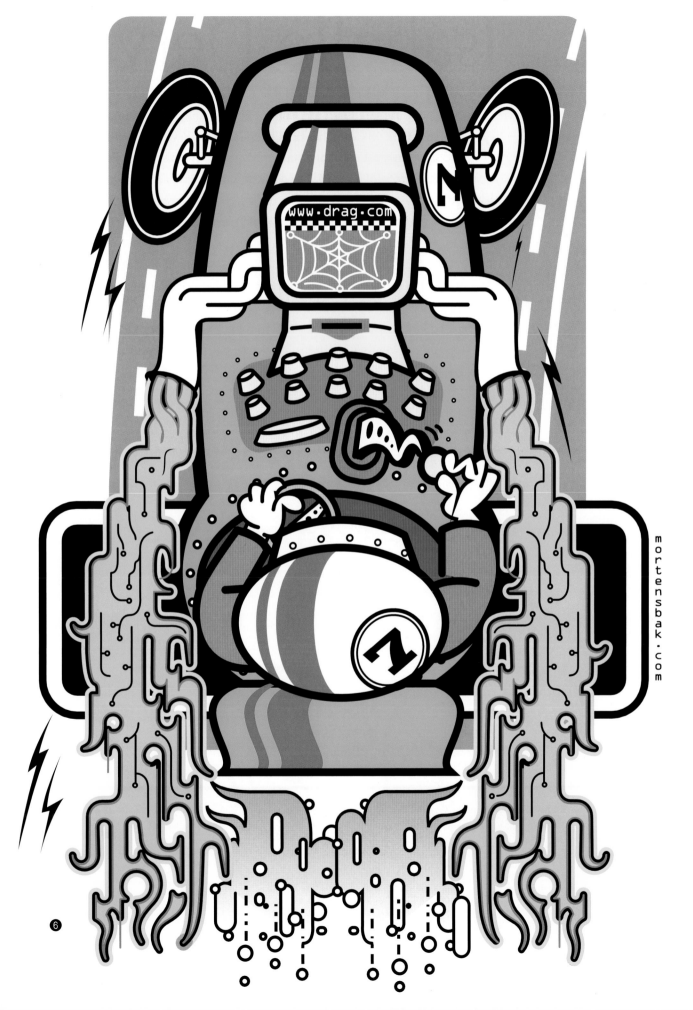

mortensbak.com

Isabelle Dervaux

A s a traditional illustrator, Isabelle Dervaux has worked in both Paris and New York, dividing her time between the two cities. Born in France, her early illustrations of amusing urbanites captured the attention of *AIGA Journal*, which wrote, "Her work has such spontaneous charm that her note sounds clear and clean above the surrounding din." In her fifteen-year career, Dervaux has completed a variety of book, magazine and advertising projects for clients in Europe, the United States and Japan. Her work has been exhibited internationally and has appeared in publicatons such as *The New Yorker*, *Vogue*, *Vanity Fair*, *Rolling Stone*, *Newsweek* and *Elle*. In addition, she has designed her own line of stationery products, created animated characters for television commercials, illustrated children's books and devised kinetic sculptures for the store windows of Tokyo's Seibu department store. Dervaux currently lives in San Francisco with her husband and their children Millie and Lucien.

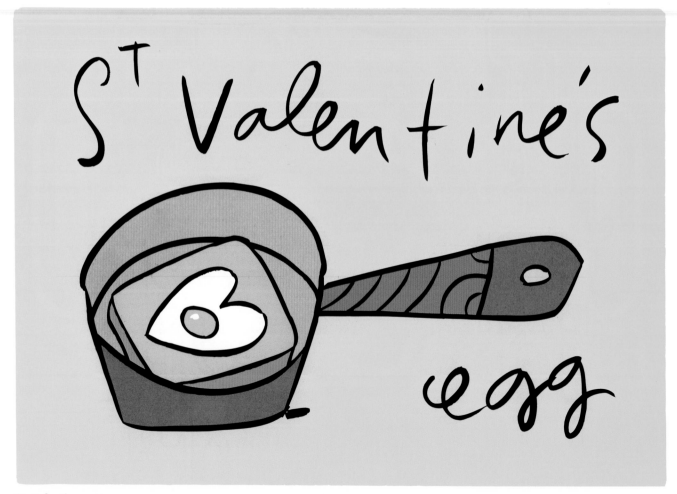

St. Valentine egg
Pinpoint Gallery: Illustration for *Winter Favorite Recipes*
Software: Streamline, Illustrator

Cheese raviolis
Pinpoint Gallery: Illustration for *Winter Favorite Recipes*
Software: Streamline, Illustrator

Crepes sucrees
Pinpoint Gallery: Illustration for *Winter Favorite Recipes*
Software: Streamline, Illustrator

Boeuf a l'ancienne
Pinpoint Gallery: Illustration for *Winter Favorite Recipes*
Software: Streamline, Illustrator

Hot cocoa
Pinpoint Gallery: Illustration for *Winter Favorite Recipes*
Software: Streamline, Illustrator

Dried fruit compote
Pinpoint Gallery: Illustration for *Winter Favorite Recipes*
Software: Streamline, Illustrator

Pumpkin gratinee
Pinpoint Gallery: Illustration for *Winter Favorite Recipes*
Software: Streamline, Illustrator

Hachis Parmentier
Pinpoint Gallery: Illustration for *Winter Favorite Recipes*
Software: Streamline, Illustrator

Roasted Butternut Squash
Pinpoint Gallery: Illustration for *Winter Favorite Recipes*
Software: Streamline, Illustrator

Comforting Polenta
Pinpoint Gallery: Illustration for *Winter Favorite Recipes*
Software: Streamline, Illustrator

Fish en Papillote
Pinpoint Gallery: Illustration for *Winter Favorite Recipes*
Software: Streamline, Illustrator

Bud Peen

B ud Peen knew he would be an artist from the first moment he gripped a
Crayola crayon. Having studied as a traditional artist and sculptor, Peen first
gravitated towards advertising in New York City and its hectic, late hour
deadlines. Moving into the "swirls and eddies" of freelance illustration in 1986, Peen
found his work moving away from advertising and towards editorial illustration, for
publications that have included *Parenting* magazine, *PC World* and *Playboy*. Later
Peen was invited by *PC World*'s art department to create illustrations in *CorelDraw*
using their only computer. Four Macs later, computers now have a permanent place
in Peen's studio. Peen has taught illustration at the California College of Arts &
Crafts in San Francisco and his clients have included companies such as Apple,
Absolut Vodka, *National Geographic*, Walt Disney and United Airlines. Peen lives in
Oakland, California with his wife Jan and his seven year old son Jasper.

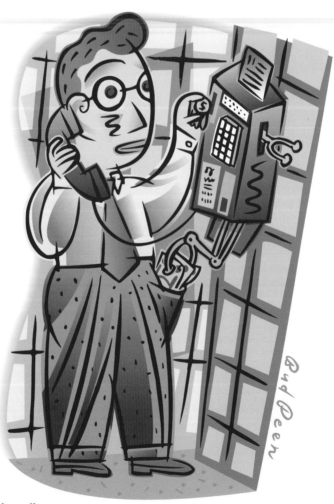

Baby Bells
InfoWorld magazine: Illustration for Bob Metcalfe's column
Software: Illustrator

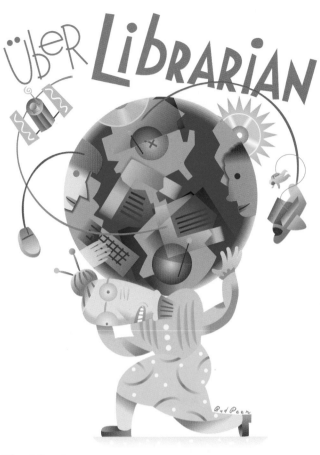

Uber Librarian
San Francisco Chronicle: Illustration for article on the changing responsibilities of librarians
Software: Illustrator

Mr. Madonna
Salon magazine: Illustration for article on a stay-at-home dad
Software: Photoshop

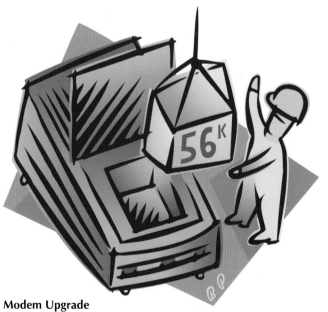

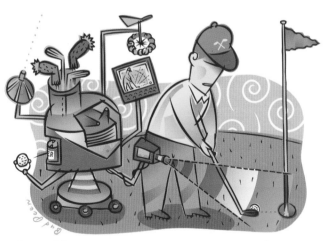

Modem Upgrade
PC World magazine: Spot illustration for "Modem-Doubler" article
Software: Illustrator

Robot Caddy
Computer World magazine: Computer golf caddy article illustration
Software: Illustrator

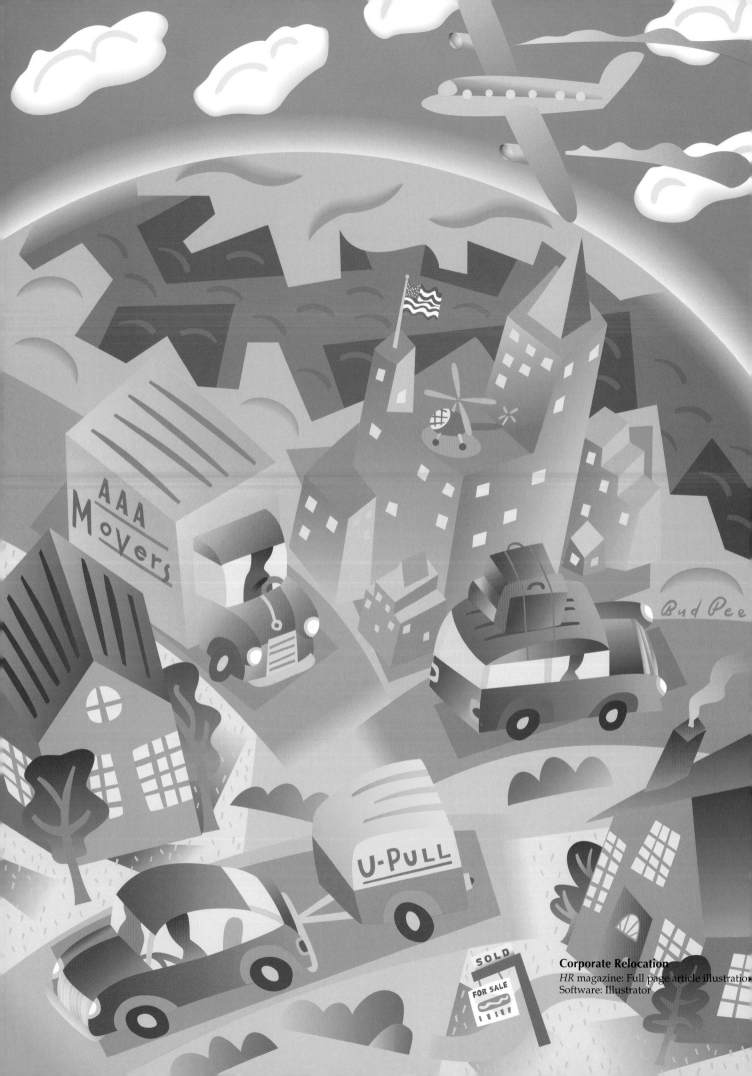

Corporate Relocation
HR magazine: Full page article illustration
Software: Illustrator

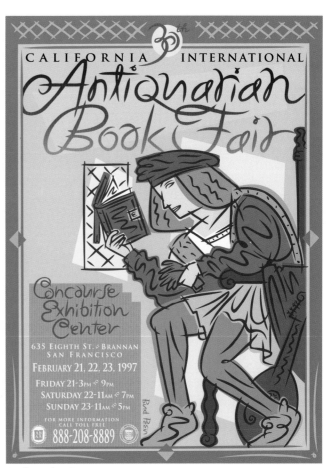

Internet World
On The Internet magazine: Illustration for article on use of satellite technology on the Internet
Software: Illustrator

Antiquarian Poster
Antiquarian Booksellers: Illustration for book fair poster, program and ads
Software: Illustrator

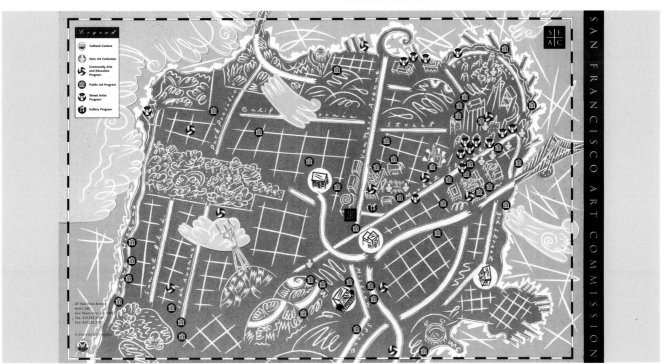

Pocket Folder
San Francisco Art Commission: Design for a folder showing the location of San Francisco Art Commision's various programs
Software: Illustrator

"Modem-Doubler" Gunslinger

Bud Peen

Assignment:

Computer magazines are the staple client of any computer illustrator, especially here in the Bay Area. However, many illustrators wince at the thought of trying to come up with a different way to illustrate the Internet, computer reviews or software products other than the all-to-familiar imagery of "globes, computers and cables." When Kate Godfrey, senior designer of *PC World* magazine called me in with an assignment for a review of a new modem software product called *Modem-Doubler*, I decided to try a different tack. The idea behind the product, explained Ms. Godfrey, was to join two 28K modems together to make one 56K. The review was less than glowing and claims of doubling speed did not come through in the tests. For the visual solution I decided to avoid the usual globes, computers and cables and instead came up with a gunslinger with a modem in each holster and bullet hole in his hat to symbolize that maybe he's not as fast as he would like to be, like the product being reviewed.

1 After months of failing to make my pressure sensitive stylus and pad create the same controlled, tapered line of my traditional quill pen and ink on vellum, I decided that everything need not be produced using the computer. I began by drawing the preliminary line work with quill pen and ink on Duralene vellum, then cleaned up the line work and scanned it into *Photoshop*. The quill pen art was scanned in and saved as a B&W bitmapped file at 360 dpi.

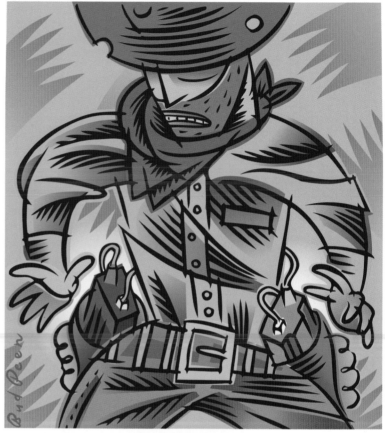

2 To convert the bitmapped artwork to vector based art, I opened the file in *Streamline* and converted the artwork to an *Illustrator* file.

3 Although *Streamline* converts the pixel-based scan to vector art, it does not recognize the art being scanned as a series of lines with open areas inside. Instead it divided my drawing into layered opaque planes of black and white which are stacked one on top of the other. To convert the stacked planes of black and white back to the original line work, I decided to convert the drawing into a series of compound paths.

4 Opening the "Streamlined" document in *Illustrator*, I made a new layer called "Background." I pulled the layer down so that it rested behind the line work in "Layer 1" of the Layers Palette. Using the rectangle tool, I drew a box in the background layer that was slightly larger than the drawing itself. Then I filled in the box with a bright color to enable me to highlight the needed compound paths.

5 First, I selected the outermost black line work. Next, while holding down the Shift key, I selected all the white areas that bordered the black area. When all the white areas were selected I chose Object > Compound Path > Make. This made the selected white areas transparent. I continued working inward, repeating the above process until all white areas were made transparent. Once the line work was converted, I no longer needed the box in the background layer, so I selected and deleted it (see fig. 5-A thru 5-C).

❶ "Streamlining"

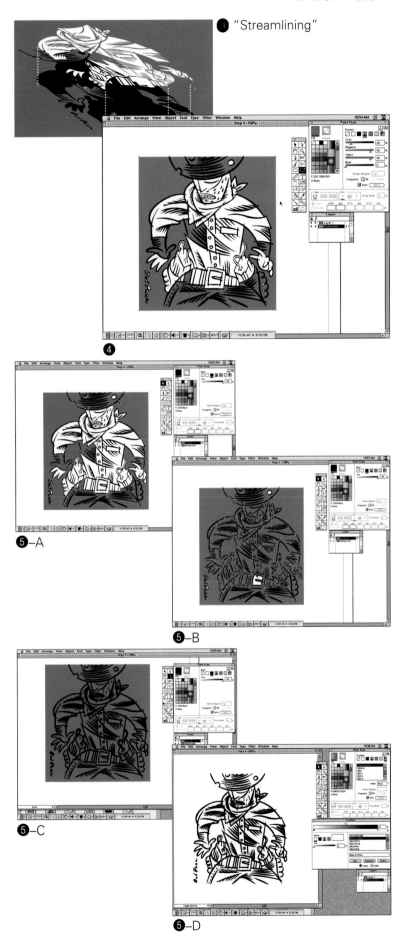

❹

❺–A

❺–B

❺–C

❺–D

6 Starting with the head of the Gunslinger drawing, I used the pen tool to sketch in flat planes of color. I worked quickly and often veered outside the quill pen line work. Over the years I have established my own color palette by making my own "*Adobe Illustrator* Start-up" palette which is found in the Plug-ins folder. I also frequently use "Import Styles" in the File Menu to import colors or gradients from previous drawings.

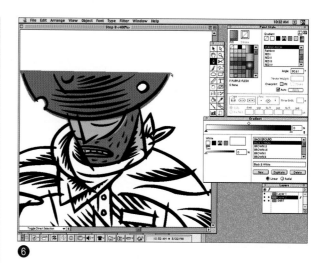

6

7 To avoid the monotony of flat planes, I used gradients that contoured roughly with the line work that I created. For the lighter end of the color transition I selected a flat color, while for the darker end, I selected the same color, then holding down the Shift key, dragged one of the CMYK sliders in the Color palette until a desired darker tone was reached.

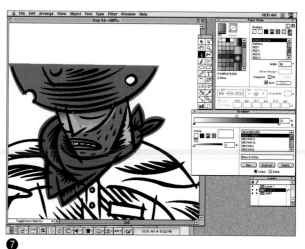

7

8 For areas with many gradients, I used masks to avoid having to line up the gradient areas with the flat color layer. First, I roughly blocked in the flat plane of color and then drew in the gradient sections. Next I used the pen tool to outline exactly where I wanted the finished area. After selecting all above elements, I selected Object > Mask > Make to generate the mask (see fig. 8-A through 8-C).

8–A

8–B

8–C

9 In creating the background, I began by drawing a square that was slightly larger than the desired final size. "Swashes" were drawn using the pen tool and filled with a muted gradient. Copies were placed by Option-dragging each to a different area of the composition. I used the rotate and reflect tools to adjust the positions of the "swashes" to give the background a wallpaper look.

9

10 To emphasize the modem images in the composition, I drew a circle behind each modem and placed in each a radial gradient blended into the background.

11 I drew a box to the finished size of the drawing, then selected all of the background and chose Objects > Mask > Make in order to frame the composition. Finally the line work was selected and changed from black to a dark muted color.

10

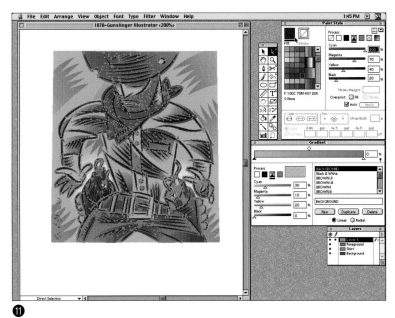

11

Dan Hubig

Dan Hubig is an editorial illustrator based in California. He began by working for the *San Francisco Chronicle*, drawing illustrations that appeared in a weekly column. In 1980, Hubig started using the computer to create his illustrations. Hubig stresses that he uses the same methods and techniques on the computer as he did when drawing by hand, but adds that by using the computer, the creative process has become both less difficult and more systematic. As a computer illustrator, Hubig has worked with a variety of clients including *InfoWorld* magazine, *The Los Angeles Times*, Chevron Corp., and *PC World* magazine in addition to his regular contributions to the *San Francisco Chronicle*. A former adjunct professor of art at California College of Arts & Crafts, Hubig now splits his time between the Bay Area and Santa Barbara, Calif.

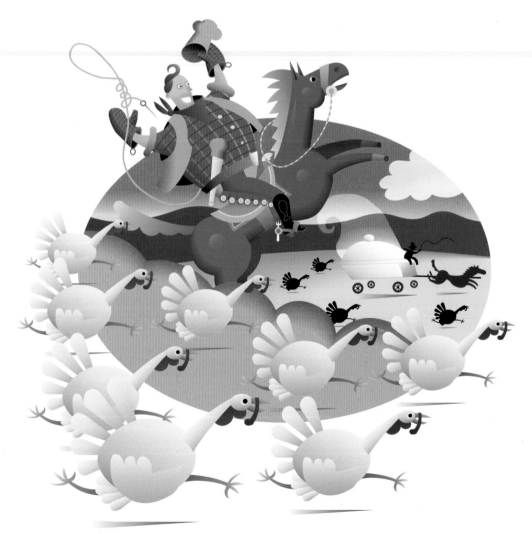

Turkey Drive
San Francisco Chronicle: Editorial illustration
Software: FreeHand

Dish TV
San Francisco Chronicle: Editorial illustration
Software: FreeHand

Letterman Does The Oscars
San Francisco Chronicle: Editorial illustration
Software: FreeHand

The NAFTA Argument
San Francisco Chronicle: Editorial illustration
Software: FreeHand

"California's a wonderful place to live, if you happen to be an orange" — Fred Allen

"The coldest winter I ever spent was a summer in San Francisco" - Mark Twain

After 20 years in San Francisco, I've recently started splitting my time between the Bay Area and Southern California. A change that is as exhilarating as it is confusing.

SF / LA Dan
San Francisco Chronicle: Editorial illustration
Software: FreeHand

Fall Arts Preview
San Francisco Chronicle: Illustration for Fall Arts Preview
Software: FreeHand

The Growing Cost of Drugs
San Francisco Chronicle: Editorial illustration
Software: FreeHand

Docs vs. Violence
San Francisco Chronicle: Editorial illustration
Software: FreeHand

Bette Midler
San Francisco Chronicle: Editorial illustration
Software: FreeHand

Dorothea Taylor–Palmer

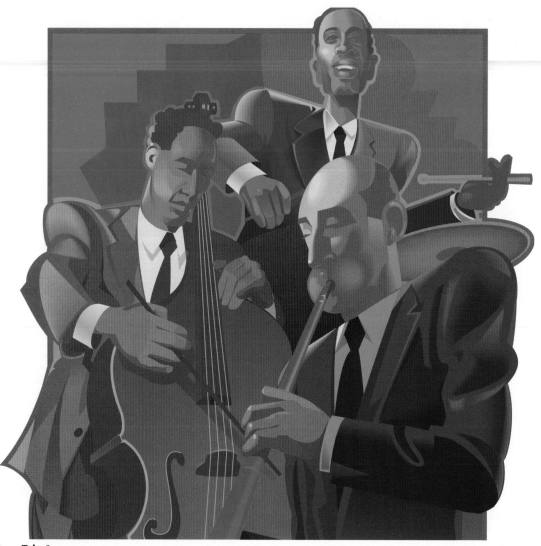

Dorothea Taylor-Palmer has been a graphic designer/illustrator for the past seventeen years. She began working on the computer in the early eighties, "cutting her teeth" on the then innovative *Illustrator 88*. Establishing TP Design in 1992 with her husband/partner Charly Palmer, her clients have included companies such as Coca-Cola, Hanes, McDonald's, Burger King and TBS. Calling her studio's approach to design and illustration "designustration," she firmly believes that typography and illustration should be integrated and work together rather than as separate entities. Her style has continually evolved over the years, which Taylor-Palmer attributes to her "IDTA" philosophy towards design, an acronym which means, "I did that already." She currently lives in Stone Mountain, Georgia with her husband and their son.

Jazz Trio 3
Adobe Systems: Adobe Illustrator gallery illustration
Software: Illustrator

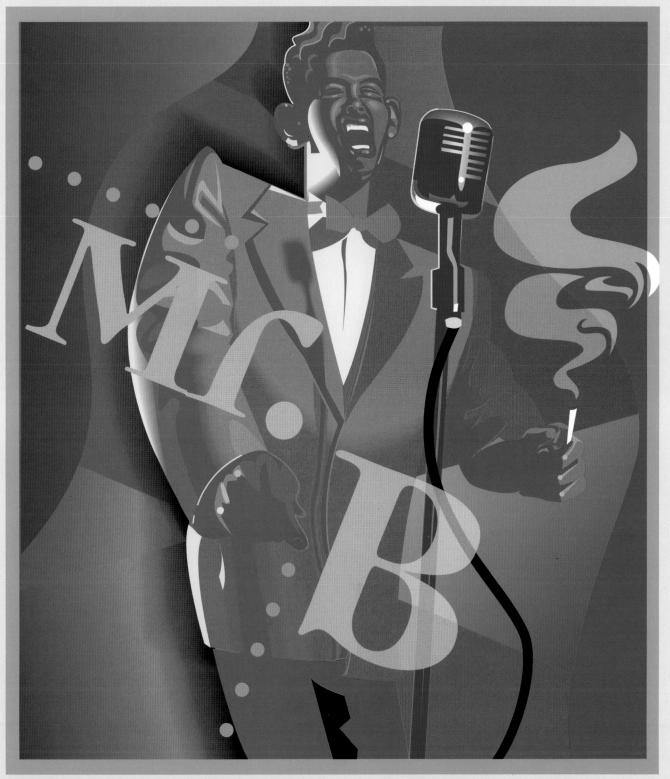

Mr. B
T.P. Design Inc.: Alternative Pick advertisement
Software: Illustrator

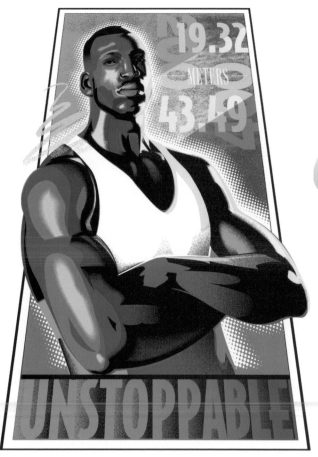

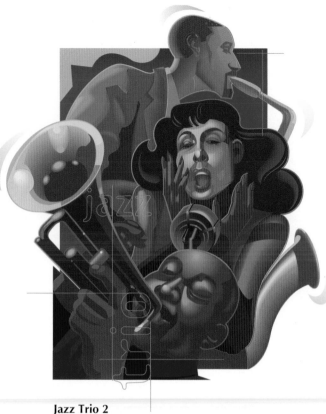

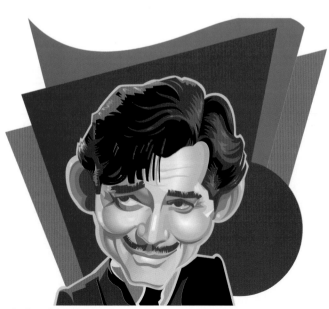

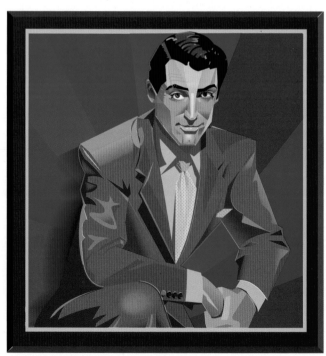

M. Johnson
T.P. Design Inc.: Self-promotion
Software: Illustrator, Photoshop

Jazz Trio 2
Adobe Systems: Adobe Illustrator gallery illustration
Software: Illustrator

Clark Gable
T.P. Design Inc.: Self-promotion
Software: Illustrator

Cary Grant
T.P. Design Inc.: Self-promotion
Software: Illustrator

◆Dorothea Taylor-Palmer

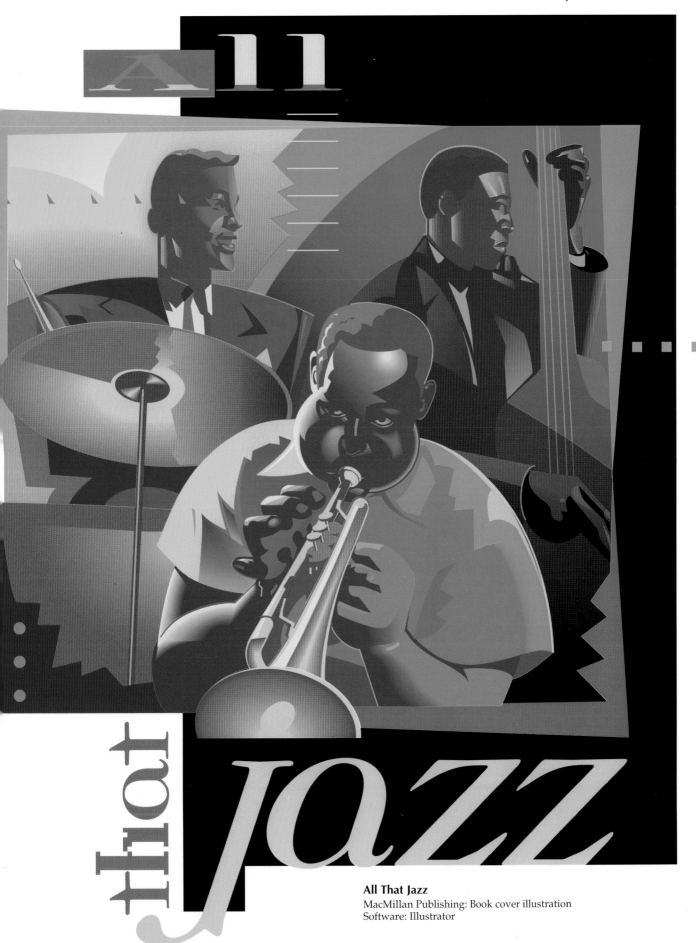

All That Jazz
MacMillan Publishing: Book cover illustration
Software: Illustrator

Scottie Pippen

Dorothea Taylor-Palmer

Assignment:

Create an illustration to be used in a company's new ad campaign. In this illustration I wanted to create a caricature of a well-known sports figure and integrate a sense of energy with an exaggerated likeness. I wanted the image to have a highly modeled yet stylized look. I also wanted to give the illusion that the image was coming out towards the viewer, so I decided to combine an *Illustrator* image with a softened *Photoshop* background.

1 First I sketched my idea for the illustration in pencil. The resulting sketch did not have quite the "action" I wanted so I ran the sketch through a photocopier while moving it slightly until I captured a better sense of movement in the image. After scanning the copied image as a PICT file, I opened the image in *Illustrator* as a template (see fig. 1-A and 1-B).

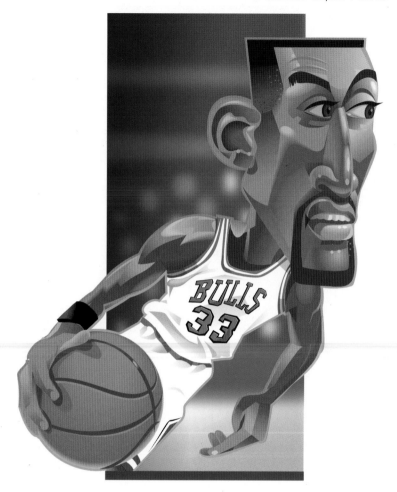

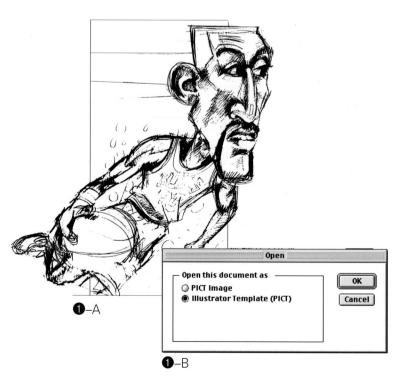

❶–A

❶–B

70

2 With the sketch in place, I began drawing over it as if it was tracing paper (see fig. 2-A). I started sketching the head area first as it was the crucial part of the illustration. As likeness would make or break the piece, I used a Pantone color guide to pick the colors I used to create the CMYK equivalents for my flesh tones. I adjust the color if it is not exactly what I want but the process ensures consistent color quality when printing (see fig. 2-B).

3 I modeled the figure by first creating the appropriate blends and gradients (see fig. 3-A). For the nose I created a blend from the previously created flesh color to a dark brown. A simple gradient was used for the plane of the nose. Although I tried to consistently use simple gradients when blending from the flesh color, for the nose, a complex gradient proved necessary (see fig. 3-B).

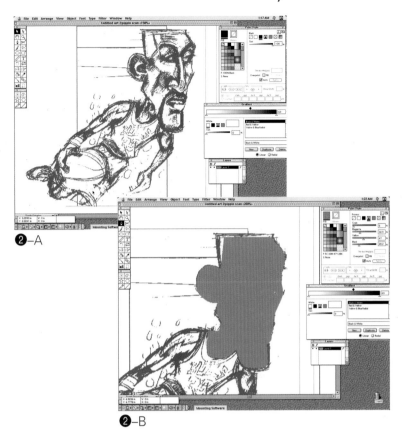

❷–A

❷–B

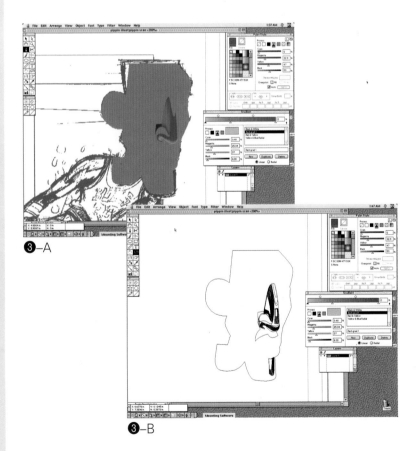

❸–A

❸–B

4 To mold the face, I continued to use various gradients and blends. Blue was introduced to create the effect of reflected light on the right side of the face. I blended from the flesh color to different blues depending on the amount of reflection, while keeping in the same family of blues (see fig. 4-A). As the area at the bottom of the nose was quite small, I selected a 135 step blend to create a "glow" (see fig. 4-B and 4-C).

5 Now that the face was well established, I moved to the arm, using similar blend combinations (see fig. 5-A). Exploring background colors, I chose an olive to make the red tones in the flesh "pop out." To create greater emphasis, I then decided to create an outline around the central figure. First a duplicate figure was created by copying and pasting. With the copied figure selected I then chose Object > Pathfinder > Unite which created an outline shape of the figure. The outline shape was given a stroke with fill on and placed over the original image, creating the desired effect (see fig. 5-B).

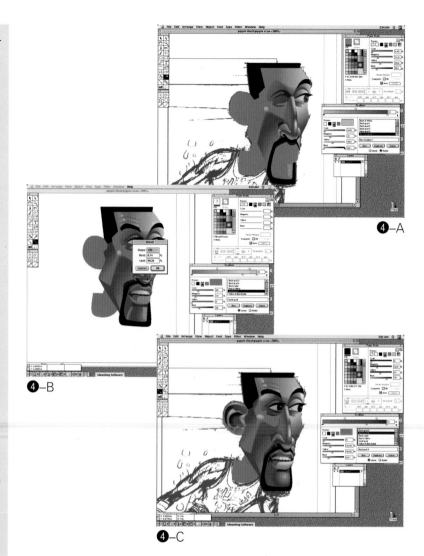

❹–A

❹–B

❹–C

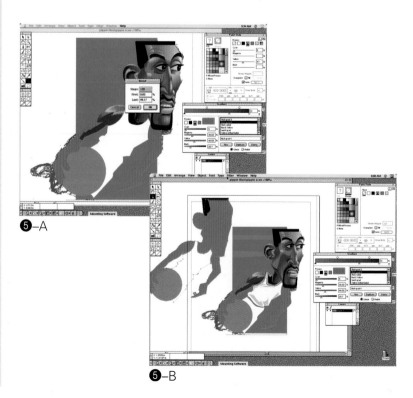

❺–A

❺–B

6 Exploring different choices for the background, I added additional shapes and colors to the original (see fig. 6-A). Deciding on a softer, blurred look, I took the created shapes into *Photoshop* where I applied a Gaussian blur. This effect also created the illusion of the figure moving towards the viewer (see fig. 6-B).

7 Moving to the jersey, I created the uneven outlines on the lettering by making copies of each letter. The fills of the original letters were then changed to black. Enabling snap-to-point, I moved the copied letters directly on top of the originals and deselected. Then selecting in turn each individual point of the overlying letters, I simply pulled back the points to reveal the black of the underlying letters (see fig. 7-A). After finishing off the rest of the uniform, I added final touches to the ball and the arms (see fig. 7-B).

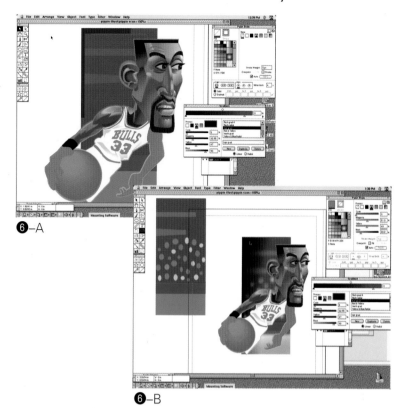

6–A

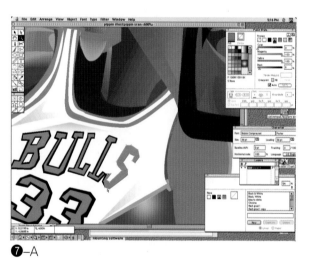

6–B

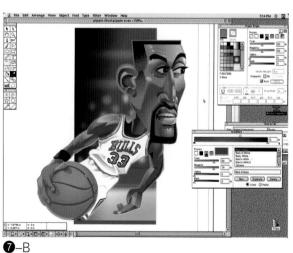

7–A

7–B

Pamela Hobbs

Illustrator Pamela Hobbs has lived and worked in London, Manhattan and Tokyo and has recently relocated to San Francisco. Her artwork has been widely exhibited and has been featured in publications including *Verbum*, *Step-By-Step Graphics*, *American Illustration* and *MacLife* in Japan. Having taught at The School of Visual Arts and The New School of Social Research, Hobbs is currently a faculty member at the California College of Arts & Crafts, where she teaches a course in Design and New Media. An experienced illustration designer, Hobbs's clients have included Paramount Films, *The New York Times*, *BusinessWeek*, Sony, Conde Nast Publications and *Wired*.

China Mask
The Creative Black Book: Cover art for annual
Software: Eye Candy, Photoshop

Java
The Red Herring magazine: Full page illustration
Software: Photoshop

New Web Techniques
PC magazine: Cover illustration
Software: Eye Candy, Live Picture, Photoshop

Digi
Digi Group Hong Kong: Poster for exhibition
Software: Photoshop

VLS
Village Voice: Literary supplement cover art
Software: Photoshop

Valentine's Day
Baltimore Jewish Times: Cover art
Software: Live Picture, Photoshop

Swatch Kids
Eight Inc.: In-store display in New York
Software: FreeHand

Increasing Your Metabolism
Sports Illustrated for Women: Cover insert
Software: Photoshop

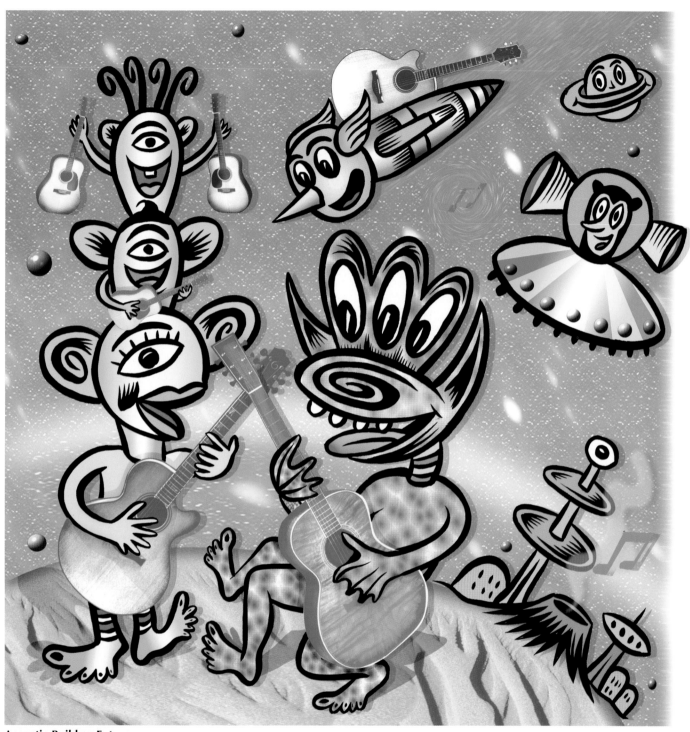

Acoustic Builders Future
Guitar Player magazine: Full page illustration
Software: Photoshop

Yoshinori Kaizu

Y oshinori Kaizu is a graphic designer/photographer who specializes in designing logo types and symbols. As a professional illustrator, Yoshinori has been a regular contributor to the Japanese edition of *Step-By-Step Art & Design* magazine. Using both Mac and Windows, Kaizu's work as an *Adobe Illustrator* evangelist can be seen on both the Adobe website and in the art gallery contained in the *Adobe Illustrator 7.0* CD-ROM. He is the co-author of both *Photoshop A to Z III* and *Photoshop 4 Creative Technique* and was the editorial supervisor to the Japanese edition of *The Illustrator Wow! Book*. He currently lives and works in Tokyo.

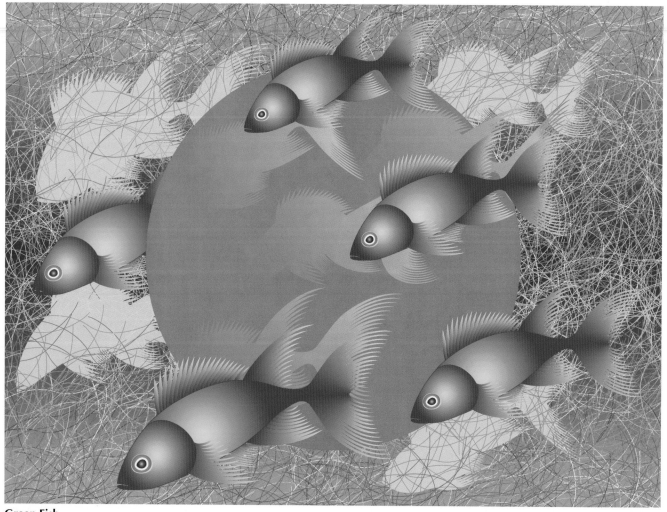

Green Fish
D Art Co.: Illustration for *Digital Creator's Tips*
Software: Illustrator

Summer Bird
Horin-sha: Cover illustration for Canon's *VI•PRO* magazine
Software: Expression, Illustrator, Photoshop

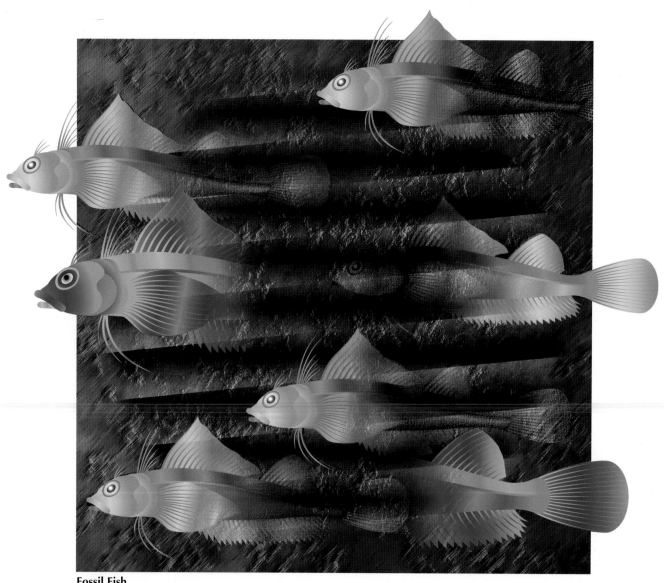

Fossil Fish
Agosto Inc.: Illustration for *Step-By-Step Electronic Design* magazine
Software: Illustrator, Photoshop

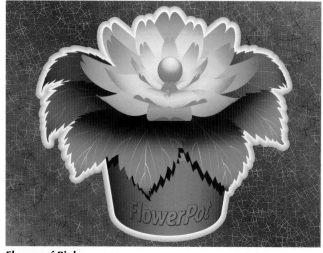

Flower of Pink
Agosto Inc.: Illustration for *Step-By-Step Electronic Design* magazine
Software: Illustrator, Dimensions

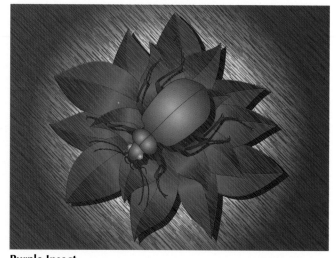

Purple Insect
Agosto Inc.: Illustration for *Step-By-Step Electronic Design* magazine
Software: Illustrator

Red Bull
SoftBank: Adobe software sales campaign
Software: Dimensions, Illustrator, Photoshop

Goddess with Labyrinth
Alps Electric Co. Ltd.: Printer sample image
Software: Illustrator, Photoshop

Toy Robot
D Art Co.: Illustration for *Digital Creator's Tips*
Software: Dimensions, Illustrator, Photoshop

Nonius
Adobe Systems: Illustrator CD-ROM Digital Art Gallery
Software: Illustrator

Flamingo in Paradise

Yoshinori Kaizu

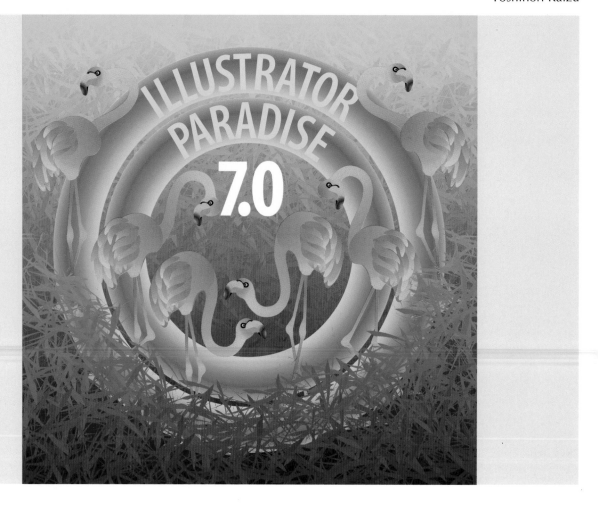

Assignment:

Create an illustration to be used in an *Adobe Illustrator 7.0* promotional campaign. The image was to be created using only *Adobe Illustrator 7.0*. Most of the flamingoes seen in the finished image were variations derived from one flamingo image.

1 Taking a stock image of a flamingo, I first used the pen tool to trace over the image, composing the various parts of the flamingo as individual objects (see fig. 1-A thru 1-C). This procedure enabled me to make variations for each part smoothly and efficiently, by simply rotating or shearing individual objects, decreasing the actual drawing time (see fig. 1-D).

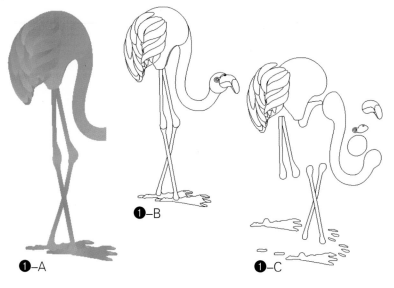

❶–A

❶–B

❶–C

2 For shapes that needed to be modified into smaller parts, I selected the knife tool to slice the larger segments into more manageable parts for later use. I chose the knife tool because, unlike the scissors tool which cuts off an object into pre-defined segments, the knife tool allowed me to slice objects into the shapes that I wanted by allowing me to specify dividing points anywhere on an object using a mouse or tablet.

3 To color the birds, I applied a custom gradation from my swatch palette (see fig. 3-A). By customizing my color palette, I was able to instantly make gradations in real time by simply dragging and dropping colors into the working gradation (see fig. 3-B). As such I found it useful to customize colors I used most frequently in tints, such as 10%, 25%, 50%, 75% and 100%.

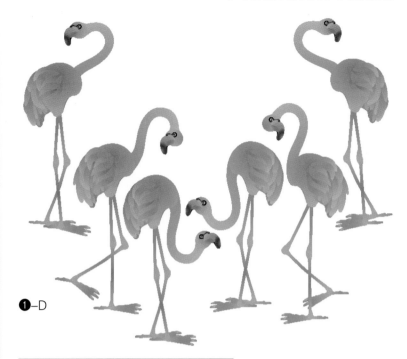

❶–D

❷

❸–A

❸–B

4 To create the donut-like background images, I first drew two circles, one larger and one smaller, and filled each with a custom gradation (see fig. 4-A). For each circle I drew a smaller concentric circle and created compound paths for each pair (see fig. 4-B). Taking the smaller of the two pairs, I placed it on top of the larger one and changed the gradation settings slightly for each, creating the desired effect.

5 Next I placed the text on the donut-like object, and pasted a rectangle with a simple gradation behind all the objects (figure 5-A). Selecting the rectangle, I chose Filter > Ink Pen > Effects, and specified the settings in the Effects filter dialogue box (figure 5-B). Behind the resulting image (see fig. 5-C), I then placed a duplicate image of the original background for added effect (see fig. 5-D).

6 Finally I made a duplicate of the entire background layer, dragged it to the top of the stack and trimmed the unwanted areas that covered the legs of flamingoes (figure 6-A). As a final retouch, I adjusted the colors of the composition slightly by selecting Filter > Color > Adjust Colors (see fig. 6-B and 6-C).

❹–A

❹–B

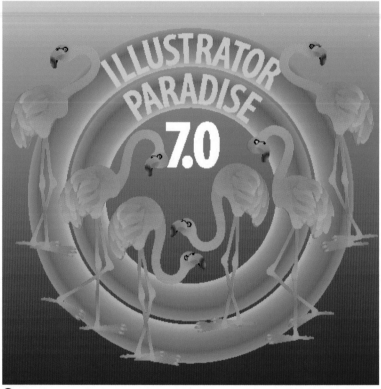

❺–A

◆Yoshinori Kaizu

Ink Pen Effects

Wood grain medium ▼

Hatch: Swash ▼ | New...
Color: Match Object ▼ | Delete
Background: Hatch Only ▼ | Update
Fade: Use Gradient ▼ | Reset
Fade Angle: 0 °

OK | Cancel | Import... | Save As...

Density ▼
57.07
☒ Preview

Dispersion ▼ | Random ▼
Range: 100 | 233 | Angle:
☒ Preview

Thickness ▼ | None ▼
Range: | Angle:
☒ Preview

Rotation ▼ | Random ▼
Range: -180 | 180 | Angle:
☒ Preview

Scale ▼ | Random ▼
Range: 10 | 1000 | Angle:
☒ Preview

❺–B

❺–C

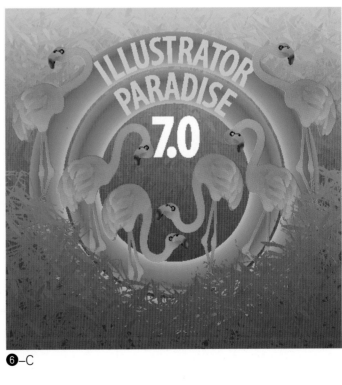

❺–D

❻–A

Adjust Colors

Color Mode: CMYK ▼

Cyan -10 %
Magenta 0 %
Yellow 0 %
Black 0 %

OK | Cancel

☒ Preview
☐ Convert

Adjust Options
☒ Fill ☒ Stroke

❻–B

❻–C

Daniel Pelavin

A native of Michigan, illustrator Daniel Pelavin began his career as an apprentice training at the local art studios in Detroit. Since moving to New York City in 1979, Pelavin has received widespread praise for his illustration and design work, earning recognition from the American Institute of Graphic Arts, *Communication Arts* and the Society of Illustrators. His work has been featured in publications such as *How*, *Step-By-Step Graphics*, *MacUser*, *Computer Artist* and *MdN* in Japan. A former instructor of lettering and design, Pelavin has also designed typefaces and is credited with having created ITC Anna and Kulukundis. Though he graduated with an MFA in graphic design, Pelavin credits his high school industrial arts classes and his apprenticeship at the Detroit art studios as his most valuable source of training and inspiration.

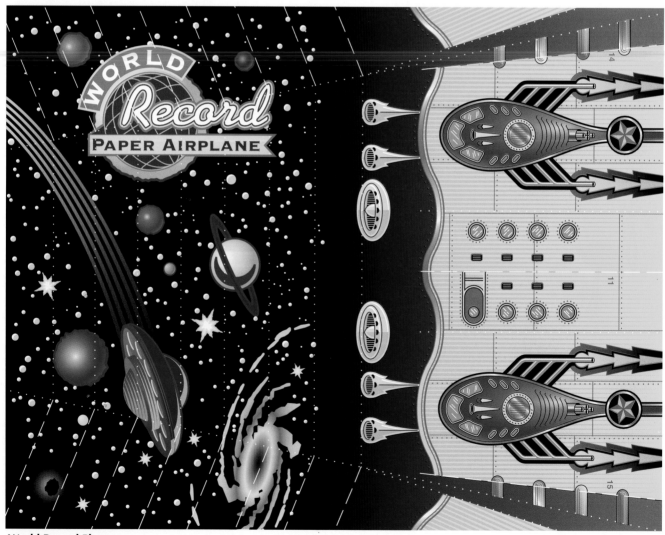

World Record Plane
Workman Publishing: Calendar featuring twelve cutout paper planes
Software: Illustrator

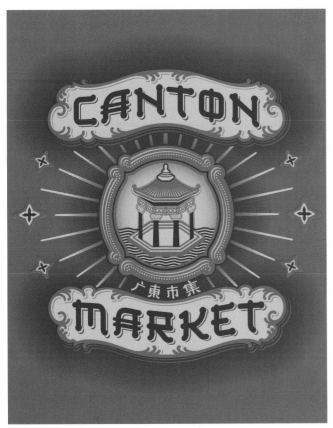

Canton Market
DFS Group, Ltd.: Logo for Hong Kong gift and souvenir shop
Software: Illustrator

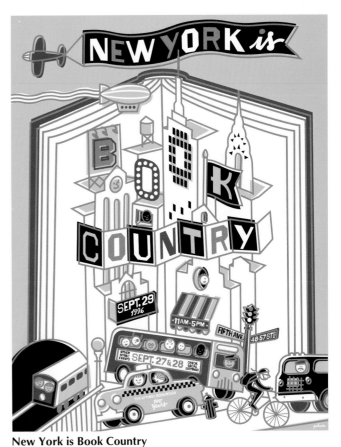

New York is Book Country
New York is Book Country: Poster for annual charity book fair
Software: Illustrator

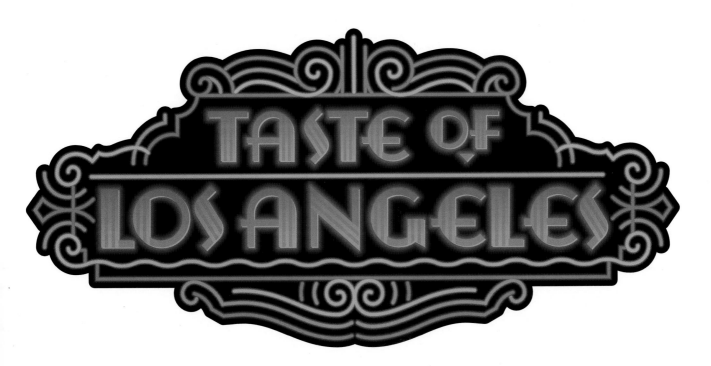

Los Angeles
DFS Group Ltd.: Logo for souvenir gift items
Software: Illustrator

Creating Selling
Selling Power magazine: Illustration for article on creativity in sales
Software: Illustrator

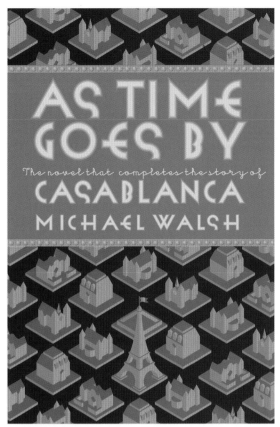

As Time Goes By
Warner Books: Book cover for sequel to *Casablanca*
Software: Illustrator

The Man With The Getaway Face
Warner Books: Book cover for a crime novel
Software: Illustrator

Original Sin
Warner Books: Cover design
Software: Illustrator

Hoover's Guide To The Top Chicago Companies
Hoover's: Book cover for a business reference guide
Software: Illustrator

Dennas Davis

Illustrator Dennas Davis is a "quirky but very friendly artist who somehow gets to make illustrations for a living." He has illustrated many children's books which include, *The Beginner's Bible*, *The Days of Laura Ingals Wilder* and *My First Hymnal*. He also illustrates for advertising and magazines and his clients have included companies such as PepsiCo, Walt Disney, *Forbes* magazine and Neiman Marcus. Currently living in Nashville, Tennessee with his wife, Ruthie, and their son and "fellow artist" Evan, Davis says he "likes doing most anything that doesn't involve a television or jumping from high places."

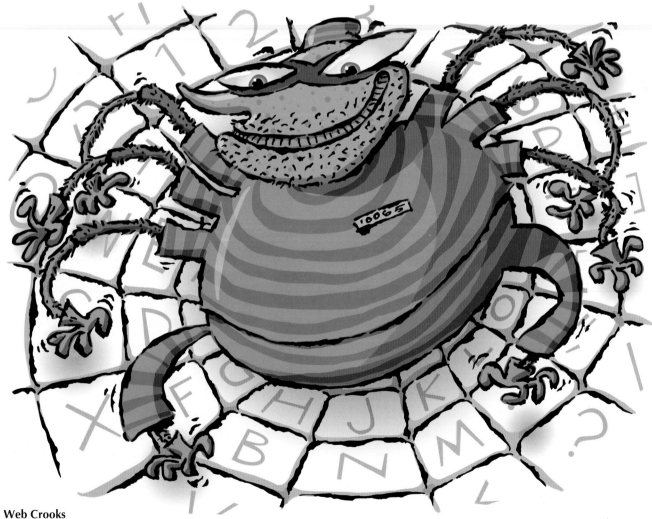

Web Crooks
Christian Single magazine: Illustration for article about crooks on the internet
Software: Streamline, Illustrator

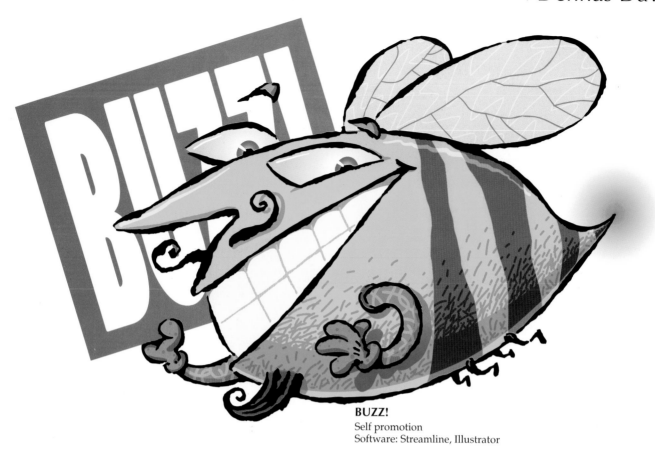

BUZZ!
Self promotion
Software: Streamline, Illustrator

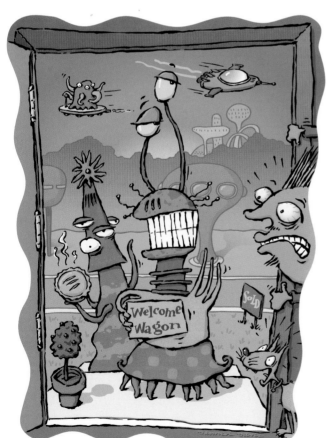

Alien Welcome Wagon
Thompson Target Media: Illustration for article about moving
Software: Streamline, Illustrator

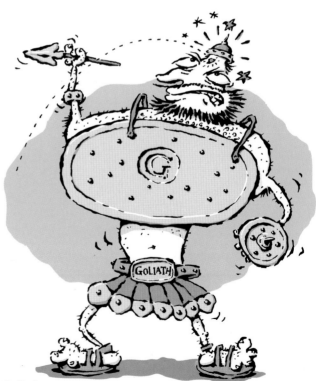

Goliath
SESAC: Advertisement illustration
Software: Streamline, Illustrator

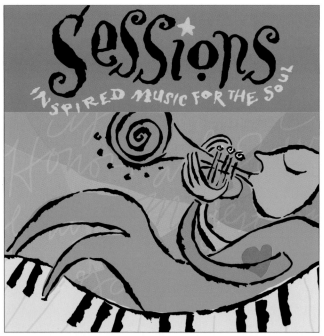

Sessions Art #4
Pamplin Music: Jazz CD cover illustration
Software: Streamline, Illustrator

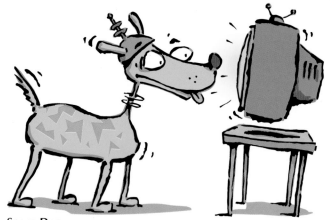

Space Dog
BSSB: Magazine article illustration
Software: Streamline, Illustrator

Purple Dragon
Illustration for a book about dragons (work in progress)
Software: Streamline, Illustrator

Bigfoot Likes Cheese
California Cheese Association: Promotional calendar illustration
Software: Streamline, Illustrator

Wasp with Candy Corn
Dayton Hudson Corp.: In-store display at Target stores
Software: Streamline, Illustrator

Mean Paper Clip
Small Business Computing magazine: Illustration for "Seven Habits of Highly Ineffective Software" article
Software: Streamline, Illustrator

Viking Man

Dennas Davis

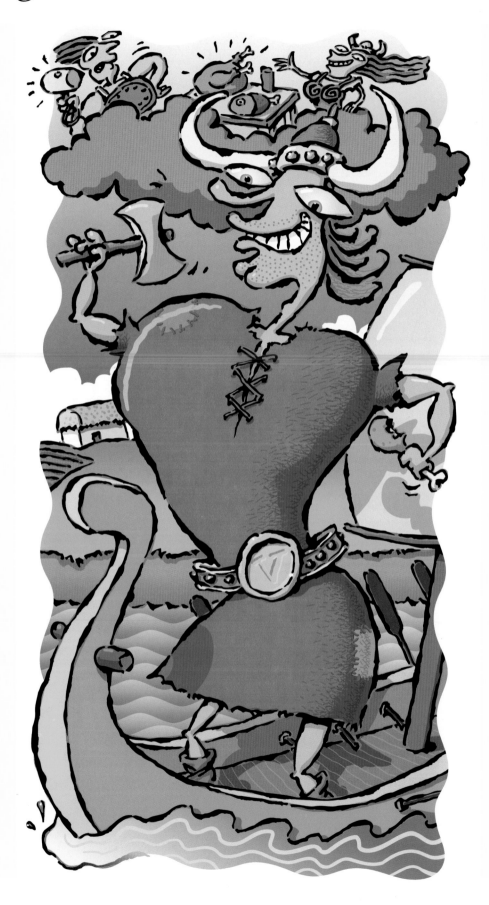

Assignment:

Create an illustration for a quarterly advertisement for a magazine called *Curiocity for Kids*. The ad was to run full page and in full color in several major newspapers. It was meant to create interest in the magazine by providing a sample of the magazine's fun style and the interesting facts one could learn about in the magazine. This particular ad focused on the Vikings and who they were.

1 After making a suitable sketch and receiving approval by fax, I inked in the sketch and scanned it into *Photoshop* at 400 dpi, saving it as a TIFF file. Using *Streamline*, I then converted the scanned image into editable line art, adjusting the settings to create the closest vector simulation of my original art. After "streamlining," I opened the file in *Illustrator*.

2 Setting up my working file, I brought up my customized palette, found in the Plug-Ins folder and created 3 layers (black, color and background) for the different components that I planned to add the composition. Next I took the scanned image and added color to the background to better see the "white chunks" that *Streamline* created on top of the black ones. Selecting the white areas, I chose Object > Compound Path > Make to convert them into transparent "holes."

3 Having placed the black areas in the black layer, I then moved the Tint slider to 25% and placed the black layer beneath the color layer. In the color layer, I began tracing over the black outlines, using the brush tool, with the width set at 2.5. To see the effects of the brush more clearly while tracing, I selected the Hide Edges command from the View menu. Once the tracing was completed, the settings of the black layer were reverted, while the layer itself was returned and hidden from view.

4 While the brush tool is good at making thick lines, I wanted to be able to make shapes the could be easily colored. To do this, I selected a brushstroke of a single object (in this case a drawn circle) and chose Object > Pathfinder > Unite. As a result the single brushstroke was converted into two distinct objects—a purple circle and a smaller circle on top which served as a "hole" in the form of a compound path. Selecting Object > Compound Path > Release resulted in two separate purple objects which allowed me to fill the top circle with any color I wanted (see fig. 4-A and 4-B).

4–A

4–B

5 After converting all my tracings to shapes, I began to fill in the large shapes at the bottom with a separate base color, using a dull gray for my tint. When I have completed the illustration, this extra color can be seen around the original black line art, which adds an additional effect to the illustration. I then began coloring in all the shapes by simply clicking onto the various colors of my swatch palette. This is the "fun" part.

5

6 For detailing, such as the chin stubble, I changed the brush tool setting to variable width and used my pressure-sensitive drawing tablet for a more painterly effect. I used this method for some of the more intricate shadow detailing. For the larger shadows on the red shirt, the clouds and the green patch on the Viking's right shoulder, I found it easier to "cut" existing shapes and then change the tints in the newly formed areas. First, using the pencil tool with line and no fill, I drew a line along the area I intended to cut. Selecting the line and the shape together, I chose Object > Pathfinder > Divide. Then Ungrouping the separate areas, I changed the colors and tints in each area until the desired effect was reached.

7 For the waves, I created a wave shape, filled it with a simple gradient and then duplicated it several times. A mask was used to make the clean wavy border, but to get some parts of the illustration to "break out" of this border required a bit more work. Choosing all of the black lines that needed to "break out," I moved them into a new layer named "highblack." This layer was placed in the uppermost position, higher than the mask layer. The colored shapes were first divided along the border with the "break out" parts also placed into a new layer and moved above the mask layer. For example, the yellow ship edge, though appearing to be one shape, is actually two separate layers. The "V" on the belt buckle was created using three identical "V"s, each slightly offset and colored for shadow and highlight, with the top "V" filled with the same color as that of the buckle.

❻

❼

Paul Woods

P aul Woods is a designer/illustrator and partner at the design firm Woods+Woods in San Francisco, Calif. As both the designer and the creative director at the firm, he spends most of his time "solving client design and marketing objectives." While Woods does not believe in "forcing" his illustration style onto a project, he does enjoy incorporating his design style into a piece when the fit is appropriate. A graduate of Philadelphia College of Arts, his firm concentrates on branding, packaging and corporate identity for a diverse range of clients. Before founding Woods+Woods, he was the creative director at SBG Partners in San Francisco and the design director at Landor Associates.

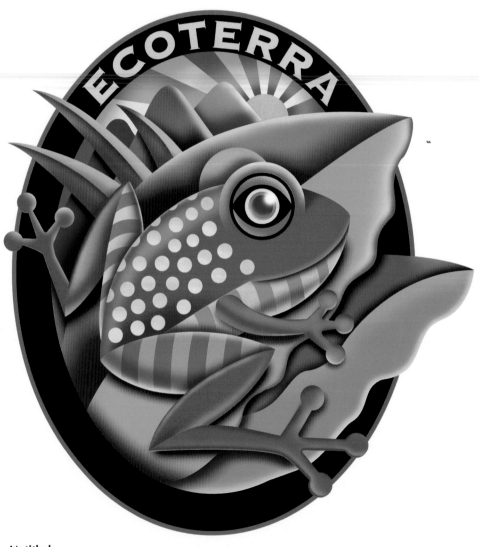

Untitled
Ecoterra: T-shirt
Software: Illustrator, Phtotshop

Transportation
Platinum Software: Art for brochure
Software: Illustrator

City Scene
Platinum Software: Art for Brochure
Software: Illustrator, Photoshop

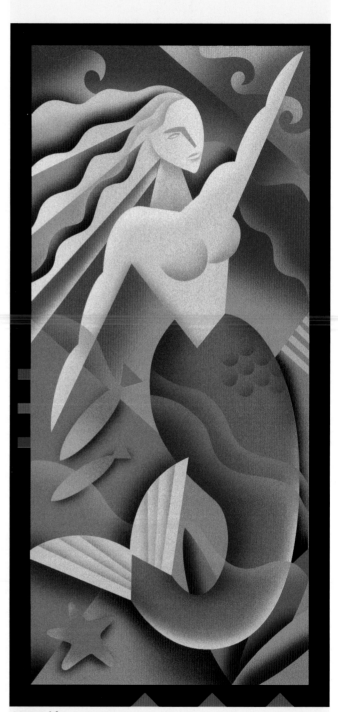

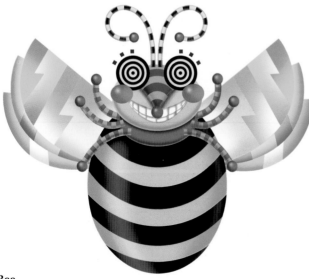

Bee
Ecoterra: T-shirt
Software: Illustrator, Photoshop

Mermaid
Gourmet Gardens: Package art
Software: Illustrator, Photoshop

3 Animals Desert
Ecoterra: T-shirt
Software: Illustrator, Photoshop

Caryl Gorska

I got into graphic design because of failure," says illustrator Caryl Gorska. "I was fired from my first job as a women's accessories buyer after just one year. I worked with an older woman who did the illustrations for the store's newspaper ads. She was really awful. The sketches I gave her for my ads were better than her finished art. I figured, if she can make a living at this, surely I can. So when I got canned, I enrolled in art classes the same day . . . " Having found her niche, Gorska went on to establish her own design studio, gorska design, and has since taken on a wide variety of projects. Her portfolio includes everything from web design to book design, illustration to signage. She has taught computer design at the California College of Arts & Crafts, and her recent projects include designing a website for a major pharmaceutical company, illustrating a book on the Internet for young adults and completing a book design and packaging project for The George Lucas Educational Foundation. Her work has also appeared in publications such as *Print* magazine, *California Graphic Design* and *The Illustrator Wow! Book*. Gorska currently lives and works with her two cats, Buster and Oskar, in San Francisco.

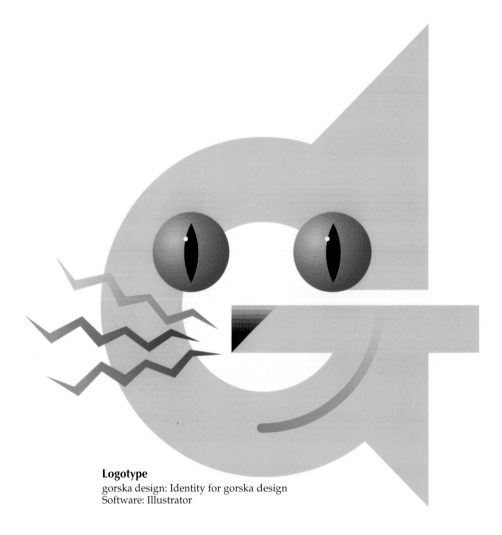

Logotype
gorska design: Identity for gorska design
Software: Illustrator

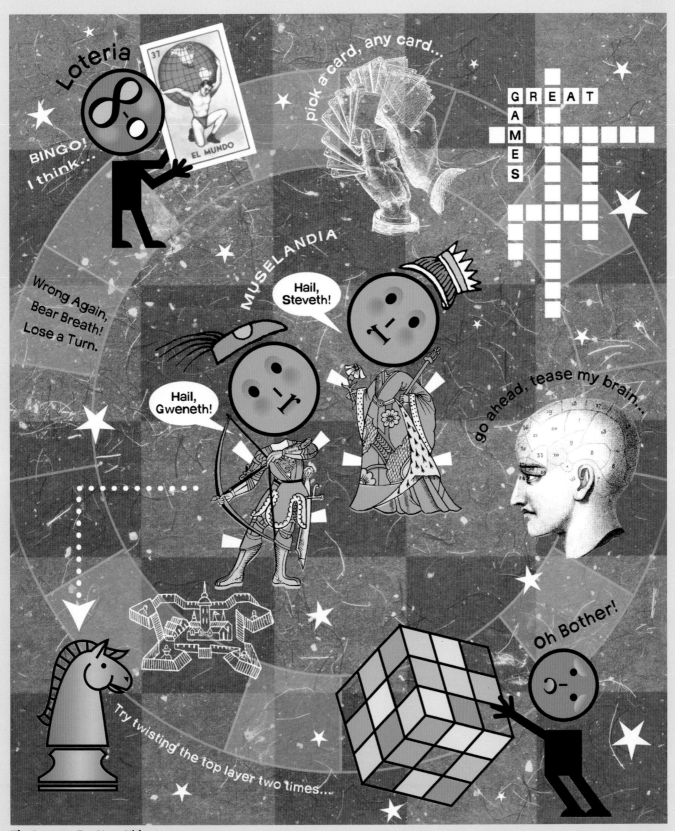

The Internet For Your Kids
Sybex, Inc.: Book interior illustration: Great Games
Software: Illustrator, Photoshop

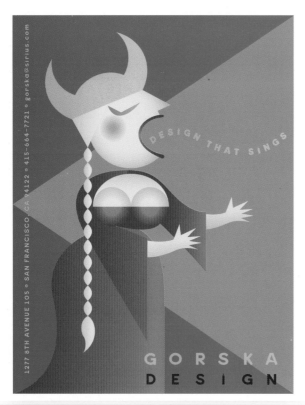

Design That Sings
gorska design: Self-promotional postcard
Software: Illustrator

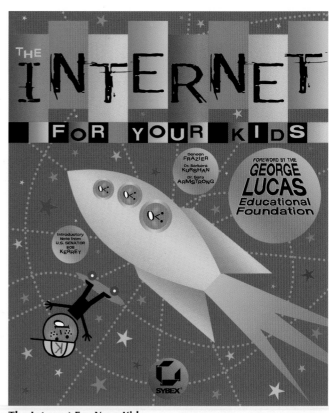

The Internet For Your Kids
Sybex, Inc.: Book cover design & illustration
Software: Illustrator

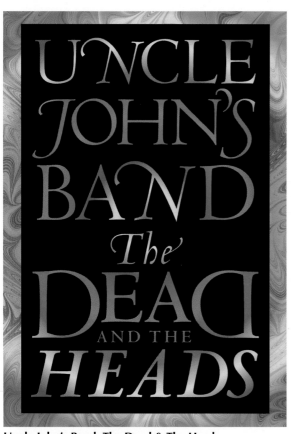

Uncle John's Band: The Dead & The Heads
Herb Greene: Book cover design
Software: Illustrator, Photoshop

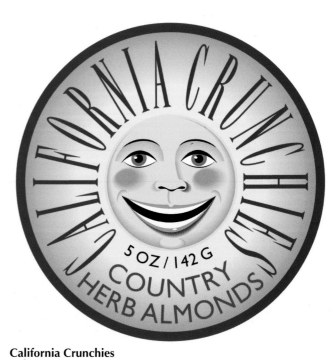

California Crunchies
Nunes Farms: Branding & packaging for specialty gift foods
Software: Illustrator

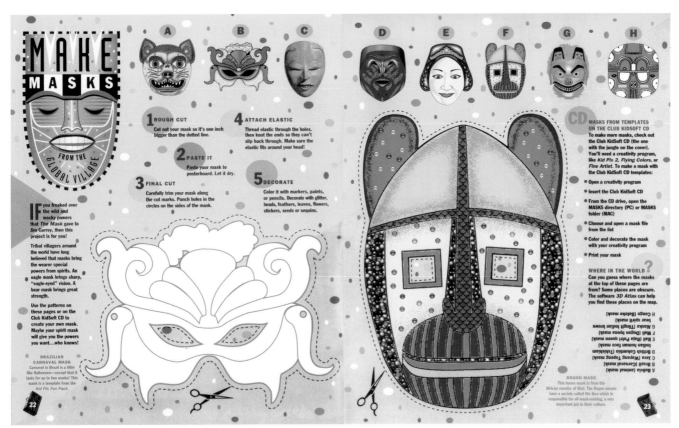

Make Masks from the Global Village
KidSoft, LLC: Magazine feature writing, design and illustration
Software: Illustrator, Photoshop, Flying Colors

Fin Fin on Teo, The Magic Planet
Fujitsu Interactive: Software branding, packaging & collateral
Software: Illustrator, Photoshop

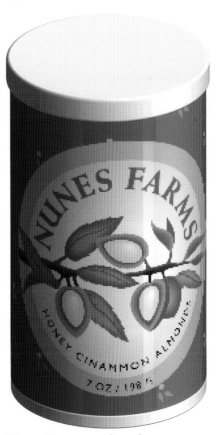

Honey Cinammon Almonds
Nunes Farms: Branding & packaging for specialty foods
Software: Illustrator

The World of the Internet

Caryl Gorska

Assignment:

Create illustrations for the new edition of *The Internet For Your Kids*, a book published by Sybex, Inc. The publisher wanted to repackage the book to make it more "hip," appealing both to older children, and at the same time, creating a flashier bookstore presence. The book is full of fun and educational projects that children can do using the Internet. My task was to create nine full page illustrations to open each chapter, from which a half dozen spot illustrations could be extracted to use in other page layouts. I chose a collage style, incorporating my own drawings, clip art and photographic images. This method enabled me to use the widest possible selection of source material, and to create images that were rich, fun and eclectic.

1 First I developed the elements that would be common to all the full-page illustrations and provide the visual consistency within the book. In creating the background texture, I scanned in a rice paper texture, which resulted in a texture resembling "outer space." As the book was to be printed in two colors, I scanned the paper in *Photoshop* as a grayscale image and then converted it into duotone. Using black plus a Pantone teal, I made several printouts while adjusting the color curves of the two inks until the desired balance was achieved.

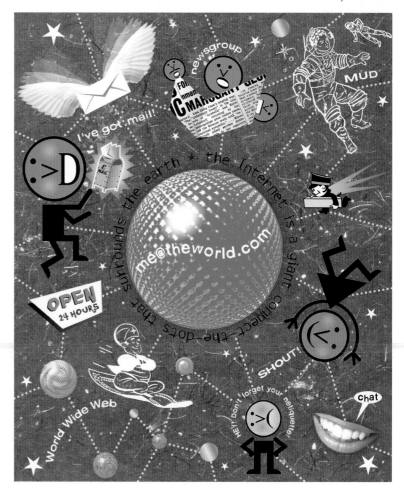

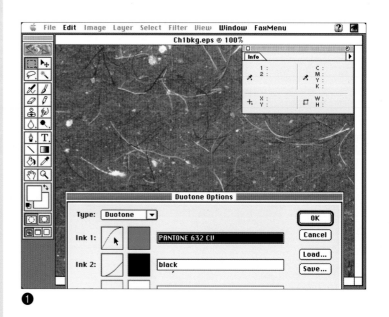

❶

2 Next I created the characters that would appear in the illustrations throughout the book. I started by making my own "smiley" faces created with type used to express different emotions in e-mail and chat rooms. I experimented with type combinations in *Illustrator*, using Times Roman type in various sizes, until I had a page of thirty or so different facial expressions. Blends and gradients were used to add shading to the faces (see fig. 2-A and 2-B).

❷–A

❷–B

3 Armed with these basic elements, I began tackling the opening illustration for "Chapter One: The World of the Internet." This chapter introduces the reader to the vocabulary of the Internet, such as e-mail, newsgroups and the Web. Selected images taken from royalty-free stock photo CDs and an archival book of vintage clip art were used to whimsically illustrate the various topics covered in the chapter. Scanning the images into *Illustrator*, I combined them with my own drawings (see fig. 3-A and 3-B). The clip art images were scanned as B&W bitmapped TIFF files, which allowed me to render the scanned images in any color.

❸–A

❸–B

4 To create the globe-like image at the center of my composition, I experimented with *Photoshop*'s native filters as well as a few from *Kai's Power Tools*. Playing with the KPT Glass Lens Bright filter and *Photoshop*'s Twirl filter, I was able to create convincing 3D globular images from scratch.

❹

The collage was to be composed of various spot illustrations describing Internet elements, so I decided to create the individual illustrations separately, combining my scans with my created *Photoshop* elements drawn in *Illustrator*. The characters' bodies were drawn as stick figures, using a combination of geometric shapes and strokes of various widths (see fig. 5-A and 5-B). In illustrating the "newsgroup," I decided to combine some of my "smileys" with scanned newsprint. First the newsprint was saved as a B&W bitmapped TIFF file. Since white areas of B&W bitmapped images become transparent when opened in *Illustrator*, this allowed me to add my own shading and modify the newsprint to create an image that resembled a folded newspaper. Drawing an object in the shape of a newspaper, I filled in the object with a gradient, which gave it the illusion of having a crease. Then, having placed the newsprint over the object, I used it to mask the newsprint, so that the newsprint appeared only within its boundaries, creating the desired newspaper image (see fig. 5-C and 5-D).

After creating eight or nine spot illustrations, I copied them all into the file where the background texture was previously saved, with the cropmarks and trim marks already defined (see fig. 6-A). I then spent many hours moving and modifying each of the elements until I had a composition I liked. In addition, I added dotted lines between the various elements to visually emphasize the inter-connectedness of everything on the Internet, as well as some stars for sparkle.

5–A

5–B

5–C

5–D

6–A

6–B

7 After the composition was completed, I went back and resolved various production/reproduction issues. For example, I wanted the photographic elements I used to blend in with the background, so I had to make the elements part of the texture background image. Using *Photoshop*, I varied the opacities of the separate layers and used the Gaussian Blur filter to generate the effect that I wanted. Last but most importantly, the artwork was checked to ensure color separation into two and only two printing plates. This can be tricky as spot color is treated as an orphan child by most graphic software.

❼

Here are a few tips on how to avoid problems

(1) Make sure that all of the software used in the project (including any layout software, such as *QuarkXPress*) names spot colors exactly the same, letter for letter. Even a one character difference in naming between programs results in an additional printing plate. In *Illustrator*, you can change the name of a spot color by double-clicking on its swatch in the color swatch palette, and editing the color name in the resulting dialogue box.

(2) When creating gradients with spot colors, use only tints of the spot color. For example, if you are going from PMS 632 to white, use 0% PMS 632 rather than white itself. Otherwise, the gradient will be converted to CMYK.

(3) If you use images placed from another application such as *Photoshop*, you will need to merge the spot colors, even if the spot colors are identically named. In *Illustrator*, you can do this simply by opening the file with nothing selected, and choosing Filters > Colors > Merge Spot Colors.

(4) Finally you can verify the number of plates by selecting Separation Setup under the File menu. The default setting creates CMYK separations, so make sure Printable Layers is selected, and Convert to Process is not checked. You can make a printout of the individual plates from here.

Clarke Tate

Clarke Tate says he "literally grew up in the art business." At the tender age of four, Tate took his first "job," taking photographs for his illustrator father. Tate briefly attended the Art Center College of Design in Pasadena, California, but after years of growing up in the business, he found himself impatient with the college and moved back to Chicago, sharing a studio with his father. Although Tate began his career using traditional media, he has since turned completely "digital." He has been active in digital illustration and his clients have included such companies as 3M, Coca-Cola and *USA Today International*. He currently divides his time between studios in the US and Europe.

Manmo Temple
USA Today International: Advertising illustration
Software: Illustrator

Japan '97
Allured Publishing: Cover illustration for Japanese conference issue
Software: Illustrator, Expression, Photoshop

Tiger Eyes
Casino Enterprises: Casino promotion
Software: Illustrator

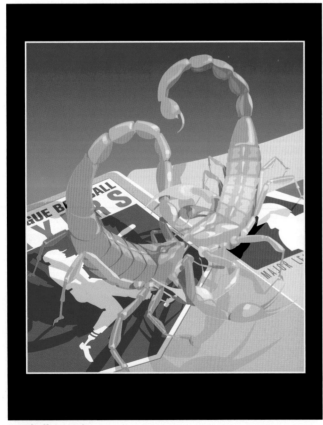

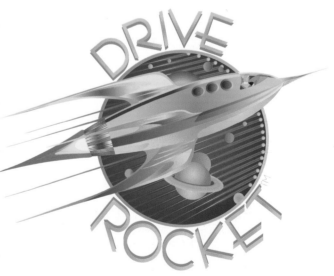

Drive Rocket
Ontrack Computer Systems: Logo illustration for a custom software
company
Software: Illustrator

Baseball Scorpions
University of Missouri Alumni Magazine: Cover illustration
Software: Illustrator

Lynn Fellman

An award-winning illustrator and designer, Lynn Fellman creates images for both print and screen. From brush strokes to vector graphics, Fellman's range encompasses both old and new artistic tools and techniques. Her lively, whimsical style has appeared in publications, multimedia presentations and websites for numerous clients nationwide. Some of her print illustrations have appeared in *Better Homes and Gardens* and Delta Airlines' *Sky* magazine. Her images can also be seen on The Microsoft Network's "The Sidewalk" websites. Fellman has taught illustration for multimedia at the Minneapolis College of Art and Design (MCAD) and served as president for a leading international multimedia professional group, the IICS. Fellman has what she calls a "virtual" studio—working out of her Minneapolis office during the summer and somewhere "warm" in the winter.

Ice Cream
AT&T: Illustration for bill insert for the Florida market
Software: Illustrator

Family Scene
HealthPartners: Illustration for a patient education brochure
Software: Illustrator

Car, House, Boat
Bankers Systems: Cover illustration for brochure series and
direct mail
Software: Illustrator

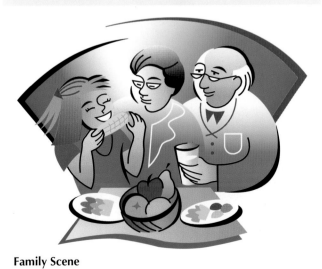

Family Scene
HealthPartners: Illustration for a patient education brochure
Software: Illustrator

Advent
Lutheran Brotherhood: Illustration for *Celebrate the Seasons of the Church*
Software: Illustrator

Microsoft Web Icons—Healthy Cooking, Night on the Town, Music Cafe

Microsoft Sidewalk: Illustrations for online restaurant reviews
Software: Illustrator, Photoshop

Jumping Student
Century College: Illustration for college's view book
Software: Illustrator

New York City
Harquin Graphics: Brochure illustration
Software: Illustrator

MARKETING

GRAPHIC DESIGN

PUBLIC RELATIONS

HOME

MAIL

INVESTOR RELATIONS

Web Icons
Nueger, Henry & Bartkowski: Icon for corporate website
Software: Illustrator, Photoshop

117

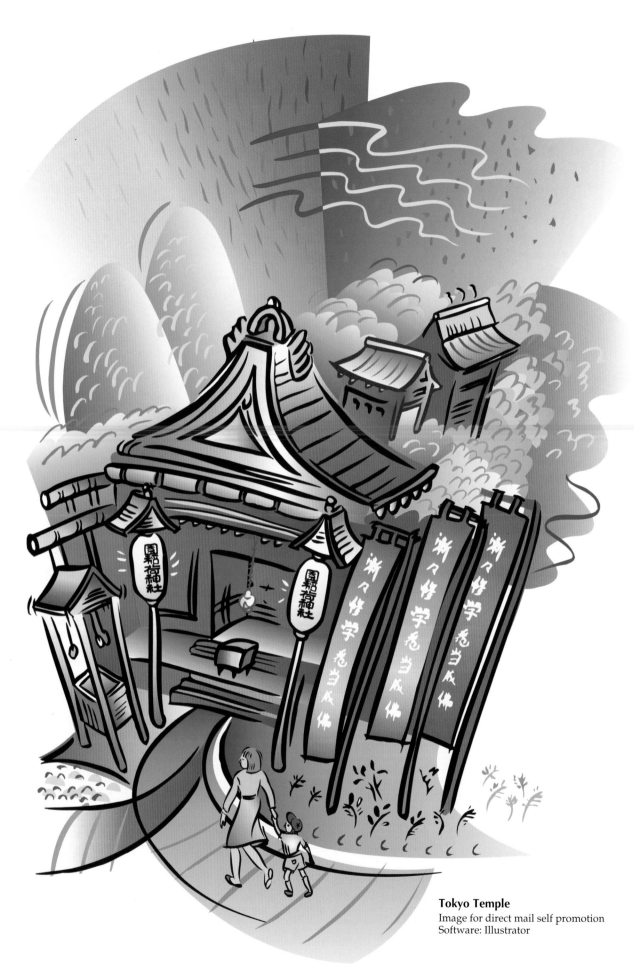

Tokyo Temple
Image for direct mail self promotion
Software: Illustrator

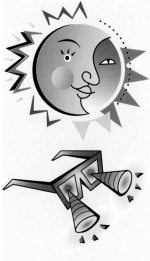

Building a Financial Plan
Chubb Securities Corp.: Cover illustration for customer advertising kit
Software: Illustrator

Balancing Toes
Better Homes and Gardens: Illustration for
"Health and Fitness" column
Software: Illustrator

Reading Student
Century College: Illustration for college view book
Software: Illustrator

Sun, Glasses, Earth, Java
Connect Time magazine: Spot
illustrations
Software: Illustrator

Soybean Growers Association Educational Kiosk

Lynn Fellman

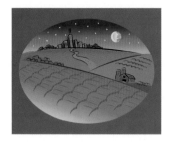 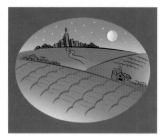 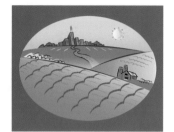 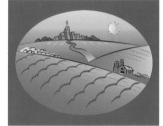

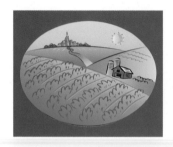 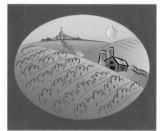 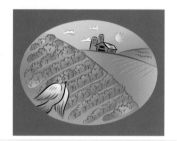 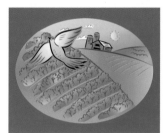

 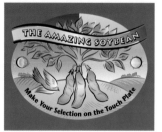

Assignment:

Create the "Attract" animation for The American Soybean Growers Association educational kiosk. The kiosk was a promotional interactive multimedia program for adults and children for use in US state fairs and trade shows. The animation itself was to consist of music and moving images on the TV, playing continuously until a visitor taps an icon on the touch plate. Since the video and script were already produced, the graphic images were to unify the elements with an overall look and feel. Multimedia productions involve many players and for this project I worked closely with each member on the team. The CDi format was selected for its large (34") screen images and high quality sound by the team leader, Blue Moon Productions. Blue Moon also wrote the script and shot the video. Seward Learning Systems supervised the interactive portions and Accompany Software provided CDi programming expertise.

◆Lynn Fellman

1 Before I began this project, I needed to calculate the correct screen size used for the final presentation. As I would be using *Director* to author the animation, I needed to know the exact size for the images to be created since *Director* uses PICT images and I would not be able to resize once the images were bitmapped. Although I knew the dimensions in pixels, I needed them to be in inches. Opening a new document in *Photoshop*, I typed in the pixel dimensions and converted to inches. With that information, I created a series of boxes in *Illustrator* to begin my story board concepts.

❶

2 Next, I sketched my ideas in a story board format for my animation concepts. The client requested an engaging, fun and whimsical animation that looped continuously every 15 to 30 seconds. Since the budget was tight and the playing time was short, I decided to avoid complicated and intricate movements by designing a series of illustrations that suggested movement by softly dissolving from one scene to the next. As it was going to be viewed at state fairs and trade shows, I added an old-fashioned feel by incorporating images with ellipses and big, poster-like type.

1

Image of a starry night and moonlit sky emerges from black stage. Art is vignette. Sound: Nature effects like crickets, bull frogs, wind etc.

2

Night scene dissolves into day. Sun replaces the moon in the same spot. Sound: birds sing, leaves rustle etc.

3

Closer view of landscape. Bird emerges from the side and begins flying across the screen. Sound: bird tweeting

4

Landscape comes closer (gets bigger). Bird exits off the stage in upper left corner.

5

Scene comes closer/gets bigger.

6

Soy plants on the hill become clearer.

7

Soy plant close up.

8

Background is added to the Soy plant. The banner scrolls accross the stage. The sun and moon rise together. "Make Your Selection on the Touch Plate" appears. Scene holds for 2 seconds and then returns to the beginning.

❷

3 Since the design for the touch plate (the printed menu in front of the kiosk) would be based on the last frame of the animation, I began illustrating the last frame first. I redrew the story board sketch to actual size and painted the shapes with black ink and brush. Then I scanned the images and converted them to outlines using *Adobe Streamline*.

4 Now I began to think about color. Though the client liked my bright colors, I knew that they would pose problems for the CDi system. Still scenes that introduce the video and the animation must use very little red and not too saturated colors to stay within the NTSC range. Colors outside the range tend to look too dark or very washed out. Though I usually use white next to saturated color next to black to create sparkle and contrast, but I found that I needed a continuous and small range of color to stay NTSC safe. Wanting to be sure I had a workable palette, I created a page of test colors. Viewing them on the CDi programmer's equipment, I made note of which colors looked best. With that information, I limited my colors and began adding them to the inked drawing.

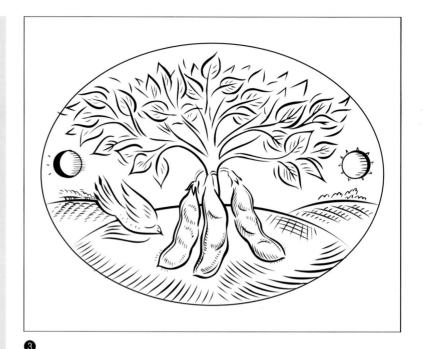

❸

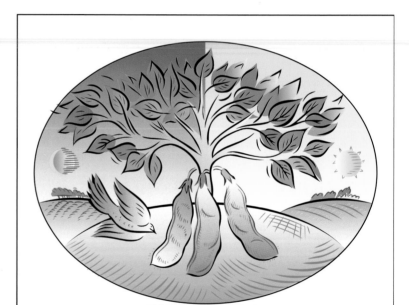

❹

5 Once I had the beginnings of the color palette and the size and shape of the main image determined, I began to work with the other scenes along with the final image. It was important to use certain elements of the drawing as animation "anchors." For example, the oval "template" was copied and pasted throughout the animation to keep consistency. The opening sequence which shows day dawning on the landscape was the same drawing locked in place with only the colors changed. The sun became the moon in the same spot. This way, when I imported the scenes into *Director*, the elements wouldn't jump around on the stage. I also began to finalized my color palette. Creating blends in the blend tool dialogue box, I added them to my palette while using the eyedropper tool to quickly change areas.

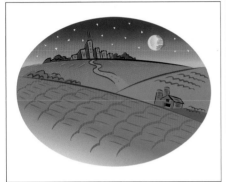 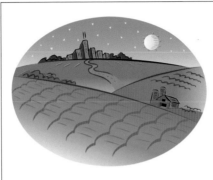 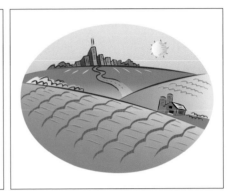

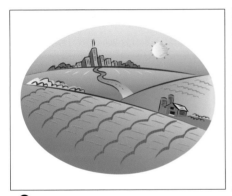

❺

6 The next series of sequences showed the "camera" zooming in on the landscape, much like a bird swooping down for a closer look. As the soybean plants get bigger and more defined, the sky gets bluer and the city recedes from view. Some of the elements are new drawings and some are resized and rotated to fit the new view. Note that I have added a banner headline and type that directs navigation to the final scene. The banner will be animated in *Director* to appear as if it is unfurling across the stage.

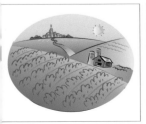 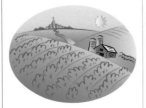 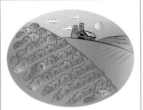 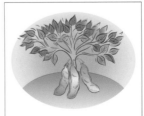 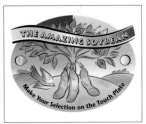

❻

7 I then concentrated on the bird that would fly across the landscape in the animation. I began the sequence by drawing a diagonal line representing the flight of the bird. After drawing the first bird, I grouped each wing separately and then copied and pasted the bird one step up along the line. For each bird image, I decided to rotate each wing 15 degrees in order to create full-wing spread 6 or 7 steps later. Selecting the left-hand wing, I carefully clicked on a "top" end point with the rotation tool while holding down the option key to get the dialogue box. Then I typed in "-15" degrees. I repeated the step for the right-hand wing, this time rotating +15 degrees. I repeated the process making sure to click on the same end point in each wing. In the last four birds, I rotated the tail as well, to give the image a greater a sense of exuberant flight. Finally, I created an outline around each bird, assigning each a 2.25 green stroke. The green "halo" allowed me to easily "clean-up" the pixelated edge after the image was imported into *Director* (see fig. 7-A and 7-B).

8 All images were brought into *Photoshop* and saved as 24 bit PICT files, since *Director* does not import vector images. The landscape scenes were converted individually. I added a purple background behind the ellipse images to fill the rectangle outline. The flying bird sequence was saved as one large image, then cut apart into separate cast members in *Director*.

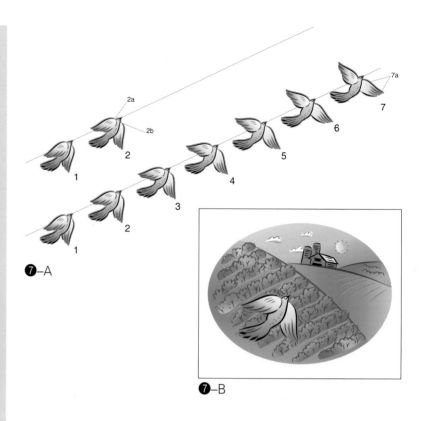

❼–A

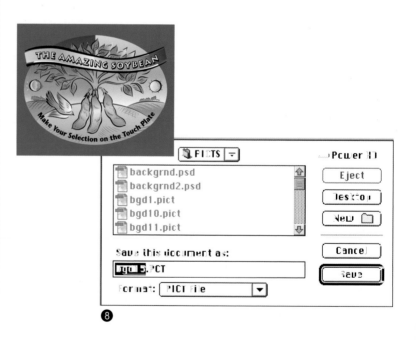

❼–B

❽

124

9 In the final animation sequence, the bird's flying steps were keyed to one spot in *Director* and then "flown" across the stage along the same flight path as determined in Step 7. The animated movement had the bird moving diagonally across the screen while flapping its wings. I did this first in one direction and then again closer up in the other direction. After client approval, I delivered the animation to the musician as a *QuickTime* file for sound synching and then to the CDi programmer for conversion to MPEG video.

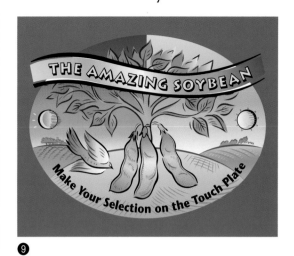

❾

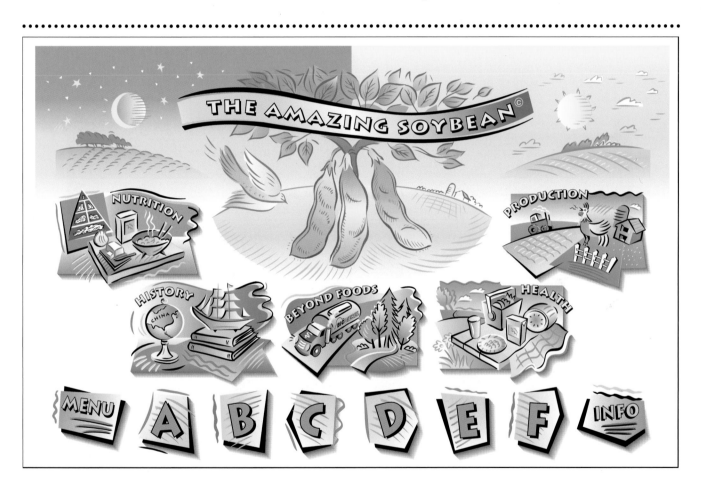

These are a few of the other project components. The touch plate is the menu or main interface for the presentation. It sits on top of a waist-high stand in front of a large 34" TV, under a 12 x 18" piece of glass. When the viewer touches one of the icons, the animation stops and the viewer is shown another graphic to make a selection. When a topic "letter" is selected, a video segment plays on the TV screen.

Michael Bartalos

Born in West Germany of Hungarian ancestry, Michael Bartalos came to the United States at the age of four, growing up in the New York area. Primarily an editorial and advertising illustrator, his artwork is characterized by bold graphic shapes cut from paper and more recently, created electronically on the Macintosh. Having studied printmaking at the Pratt Institute, his recent projects have included designing Swatch watch faces, stamps for the US Postal Service, various corporate identities for Nickelodeon and the Microsoft Discovery Bus, a mobile learning center that tours schools and museums across the United States. Bartalos currently lives in San Francisco and enjoys traveling and working abroad.

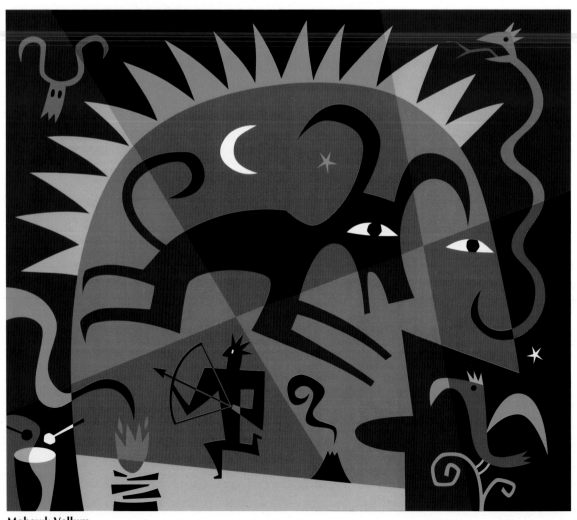

Mohawk Vellum
Mohawk Paper Mills: Front and back cover art of paper swatch booklet
Software: Illustrator

Hi Tech Surf
Mix magazine: Editorial art
Software: Illustrator

Cross Currents
Federal Reserve Bank of Boston: Corporate publication art
Software: Illustrator

Information Access
In magazine: Editorial art
Software: Illustrator

Tropical Beat
Koolwraps: CD gift box design
Software: Illustrator

Multilingual Internet
Red Herring Communications: Editorial art
Software: Illustrator

DQ166
Design Quarterly: Cover art
Software: Illustrator

China and Morocco
Butterfield & Robinson: Calendar art
Software: Illustrator

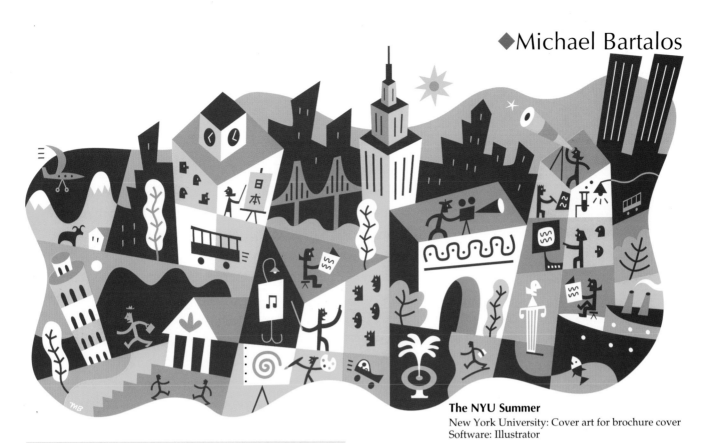

◆Michael Bartalos

The NYU Summer
New York University: Cover art for brochure cover
Software: Illustrator

Marathon
United States Postal Service: Commemorative postage stamp art
Software: Illustrator

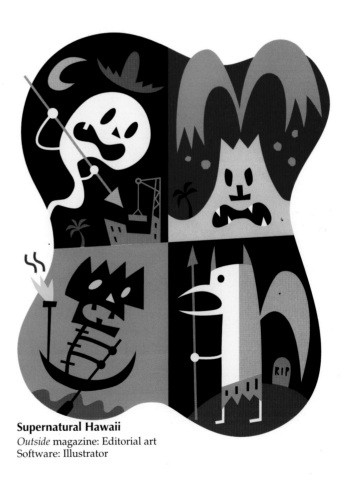

Supernatural Hawaii
Outside magazine: Editorial art
Software: Illustrator

Ron Chan

Ron Chan is a freelance illustrator based in the Bay Area. After graduating from San Francisco City College, Chan moved to Kansas City, where he worked for a major greeting card company. However, Chan soon realized that he could never draw eyes large enough to satisfy the company, so he returned to San Francisco and began to work freelance. In 1984, he began working at the *San Francisco Chronicle*, where he began to use the computer to design and illustrate covers for the newspaper's Sunday supplement. Since then his art has appeared all over the world and he is often called upon to do seminars on his work and techniques. His clients have included Visa, ITT, *Macworld* magazine, Estee Lauder, and Sun Microsystems. His work has also been widely profiled, with features in *Communication Arts*, *HOW* and *Step-by-Step Electronic Design*. Chan works out of his home in Mill Valley, Calif., where his wife Nancy serves as his senior art director.

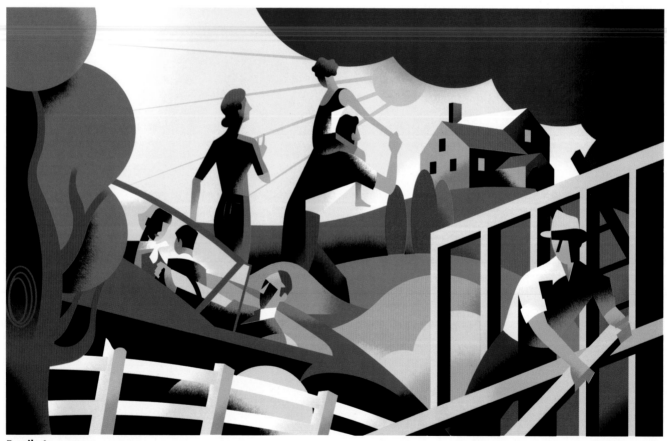

Family Insurance
Your Money magazine: Illustration for article about different types of insurance
Software: Illustrator, Photoshop

Internet
Bell Canada: Illustration about the internet for *Solutions* magazine
Software: Illustrator, Photoshop

Catellus
Catellus Development Corp.: Illustration for promotional mousepad
Software: Illustrator, Photoshop

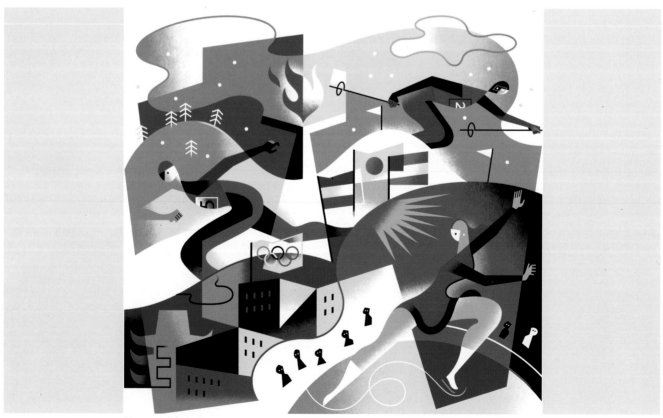

Nagano Olympics
Visual Strategies: Illustration for special US newspaper sections about the Olympics
Software: Illustrator, Photoshop

StreetTalk
Banyan Software: Package illustration for networking software
Software: Illustrator, Photoshop

Illustrator Tips & Techniques

by Ron Chan

1 Masking Layer

Setting up your illustration correctly from the beginning can help make your work proceed much faster. I like to set my illustration up with usually three or four layers.

From the bottom up, the first layer is the "Drawing

Layer." This is the layer where the entire drawing takes place.

The second layer is the "Grid" layer. Since I almost always use a grid as the basis of my drawings, this grid (which is actually a series of rules that are turned into Guides) is used as Snap To points when I retrace the drawing using the Pen tool.

If the illustration includes text, then the third layer is my "Text" layer. Especially when using type that has not been Outlined yet, this layer enables you to get type out of the way quickly, cutting down on font redraw time.

The last layer (or top layer) is always a "Mask" layer. The only object on this layer is a rectangle of the final cropped size of the illustration. By making this the top layer, selecting all, then choosing Objects > Masks > Make,

anything you draw on your "Drawing Layer" that extends beyond the final size will be cropped off. Even if you Hide this "Mask" layer, the cropping will still take place.

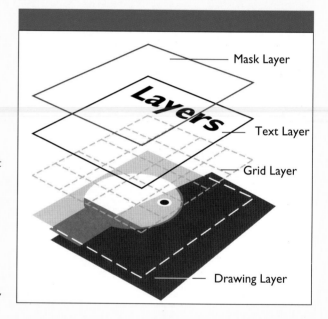

2 Enclose Shapes Quickly

To enclose an object without selecting the two end points, select the entire object (or while in the Direct Select mode, hold down the Option key while clicking on any part of the object) and press Command–J.

136

◆Ron Chan

3 ▶ Paste in Front/Back

⌘–F

⌘–B

Paste in Front/Paste in Back (Command–F and Command–D) is the most useful "layering" tool there is. Unlike the normal Paste command, which pastes the object in the clipboard to the center of your viewing area, Paste in Front/Back will place the object at the exact x-y coordinates where it was cut from. If an object(s) is selected, Paste in Front/Back can quickly put any object in the right "layer." You can go months and never use the normal Paste or Bring to Front/Back commands.

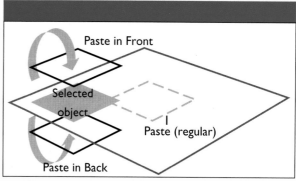

Note: Paste in Front/Paste in Back can also be a powerful tool for Pasting into Grouped Objects and Masked Groups of Objects.

4 ▶ Too Many Objects

⌘–Option–3

When your illustration has too many objects, it becomes harder to work on a single object. In *Illustrator* , you may choose to bring the object you are working on to a new layer and then hide the other layers. However, your object will go out of order so this option may be impractical (especially for complex illustrations).

An easier way would be to hide the unnecessary objects on your screen. This is easily done by selecting the object you wish to work on and pressing Command–Option–3. This will hide all objects except the one selected and will also work a lot faster than Shift-Selecting unwanted objects.

Note: Along the same lines, to lock all but selected objects press Command-Option-1.

⌘–Option–1

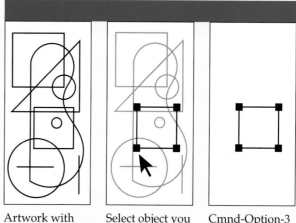

Artwork with many objects

Select object you wish to work on

Cmnd-Option-3 hides unselected objects

5 ▶ Using the Control Palette

The Control Palette enables you to move, resize, scale and rotate without having to have to go into the respective menus or tools. Holding down the option key while pressing enter will duplicate the object. Like the info bar in *Quark XPress*, this is especially handy for page layout in Illustrator. Also works great for sizing objects from the center (ie. circles).

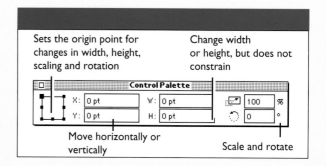

Sets the origin point for changes in width, height, scaling and rotation

Change width or height, but does not constrain

Move horizontally or vertically

Scale and rotate

6 Make Soft and Divide Filters

In many situations it is better to use the Make Soft filter instead of the Divide filter when "cutting up" objects (especially type and complex objects).

Before

After

Soft Filter

Select: Same Fill Color

Divide Filter

Using the Divide filter will cut the path up for you, but you have to manually direct select each path in order to change the color.

By using the Make Soft filter you only have to Direct Select one path, then use Select: Same Fill Color filter to choose all the paths, then change the color.

After that, you can choose to Cut the paths to the clipboard; use the Group Selection pointer to select the remaining objects. Then Paste in Front and Group the paths you have just pasted. This way you can change the color of all the paths just by clicking on one of them.

7 Drawing Smooth Curves

When drawing curves remember to use as few points as possible. A perfect circle only needs four anchor points! Keep this in mind when drawing your curve.

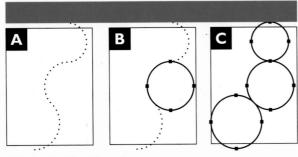

(A) Start with a Template.

(B) Hold down the Shift key and create a circle that matches up to the curve.

(C) Create circles for the other sections of the curve.

(D) Cut the sections of the circle that overlap each other. Then delete unwanted segments.

(E) Move each segment and snap-to the intersecting points. Select the overlapping points then Join, making sure that the Smooth option is selected.

(F) Copy and Paste in Back of the original curve, while the duplicate curve is still selected, make it into a guide.

(G) Using the Delete Points tool, delete the unnecessary points.

(H) Since the original circles were based on perfect circles, you should be able to find many control points that will be easy to manipulate by moving those points while holding down the Shift key. The Guide under the circle will tell you how far you are from the original curve.

(I) That's it!

TIPS & TECHNIQUES
8 Blending Backwards/Forwards

Blends (as opposed to Gradients) are actually two shapes which are repeated until one shape "blends" into another.

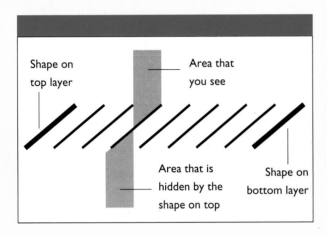

· Any shape on the bottom layer will blend into the shape on the top layer.

· In other words, the length and color of your blend depends on which layer is on the top an which layer is on the bottom. Since the bottom layer is partially hidden by the shape on the top layer, the color of the top layer will be predominant.

TIPS & TECHNIQUES
9 Types of Shape Blends

There are many occasions where using shape blends are preferable to gradients. For example, when you need to start or stop a gradient at an exact point. Here are two quick ways to come up with a shape blend.

Advantages: As opposed to a blend that is created without a common side (see fig. A), a common side blend gives you precise control of the area where you want the graduated tone to fill. It is also much easier to select the entire shape, including the blend, because all the blended shapes can be selected by it's common side. Another plus is that a common side blend is a lot cleaner visually than blending two unrelated shapes.

Start with a shape

Duplicate shape and paste in front of the original shape

Drag one side of the top shape inward, to where you want the blend to end

Blend

Blend created without a common side

Blending two Objects into Each Other

A situation might arise where you will have to blend two objects into each other. In order to do this, you must be able to pick a color in the gradient as an ending color. However, when using the gradient tool, the colors are computer-generated and hidden from view.

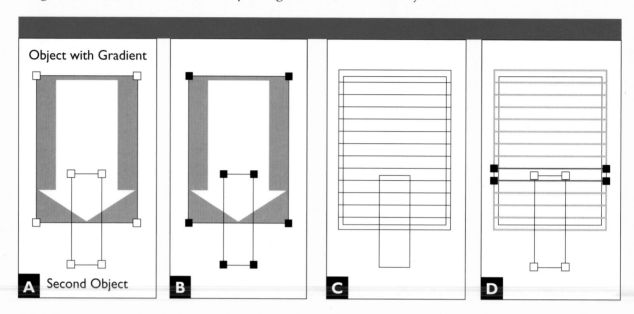

(A) Fill one object with a gradient color.

(B) Select only the gradient object and go to the object menu and select expand.

(C) This will turn a gradient fill into an object with shape blends

(D) Find the second object and carefully select the blend step which corresponds with the end of the object. This blend step will be the end color of your gradient of the second object in the original file.

Creating Paths from Illustrator to Photoshop

(A) In *Illustrator*, use the Trim filter to create paths with no overlap.

Note: Save this file separately in case you need the paths at some later time. (I use the suffix ".outline")

(B) Select All and Copy.

(C) In *Photoshop*, Open *Illustrator* artwork file and rasterize to desired resolution. (Artwork must remain at 100% or the Paths created in *Illustrator* won't register)

(D) Paste *Illustrator* outlines into *Photoshop* as Paths.

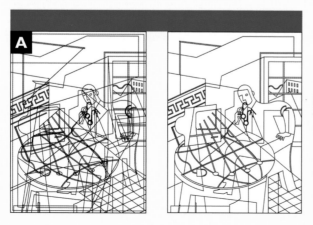

(E) In the Path palette, Click on the Work Path layer. Then using the Direct Selection tool, marquee select all the paths (You might have to reduce the Canvas area in order to see all the paths.

(F) Move the paths until they register to the artwork. **Note:** Sometimes moving all the paths at once might require too much memory. If that happens, just marquee select a portion of the paths (Top half, quarter, whatever) then Cut and Paste into a new Path Layer, then move the paths. (If you try to do this in one layer, it might be too hard to select the paths that weren't moved.)

TIPS & TECHNIQUES

12 ▶ Using TIFFs As Templates and Art

Illustrator 6.0 enables you to import 1-bit TIFF files and colorize them. By using this feature as a template, you can get a much higher resolution picture to trace than you can with the usual PICT template. Although screen redraw will be slightly slower than a PICT template, 1 bit TIFF images are much faster than placed EPS images.

The only downside to using TIFF images as a template is that there is no preview in artwork mode. To get around

this, you can put the TIFF template on it's own layer and work on a separate "Drawing Layer." You can then colorize the "TIFF Template" to a muted tone which will let you draw on top of it. When you wish to work in artwork mode, you just Option click the eye on the "Drawing Layer", which will turn off the preview for that layer, but still keep the "TIFF Template" layer in preview mode.

If you want to drop colors behind a 1 bit TIFF image, Option Drag (Copy) the image to a separate layer above the "Drawing Layer." You can then colorize that TIFF image and hide the layer when necessary.

TIFF Overprint Layer

Drawing Layer

TIFF Template Layer

Index of Artists